Katie, Jake,
Christie & Tony,
It has been very nice
getting to know you guys
during Pinewood Swim Season
and now Ashborough. Good
Luck on your move!
Rachel, Jenn
& Garrett

You have been a
wonderful addition to the Pinewood
family. Thank you for sharing of your
time with Sunshine, Guitar, and mostly for
adding Hampton to so many of your family
events! Hampton is fortunate to have you!
Best of luck to you all!
At, Dana Kennedy
Hampton Dennis!

THE PONDS JUST WON'T BE
THE SAME WITHOUT YOU GUYS!
WE WILL HAVE SUCH GOOD
MEMORIES OF NEW YEARS & XMAS
PARTIES, SEEING YOU RUNNING THROUGH
THE TRAILS (AND TONY! LEAVING YOU
IN THE DUST, CHRISTINE!) AND SEEING HOW
FAST KATIE & JAKE HAVE GROWN!
WE LOVE YOU! — Darrel & Sara

Alles Gute!
Vielen Dank!
Jodee
See you at
the Maroon 5
concert!!!! I ♡ you!!
-Tessa

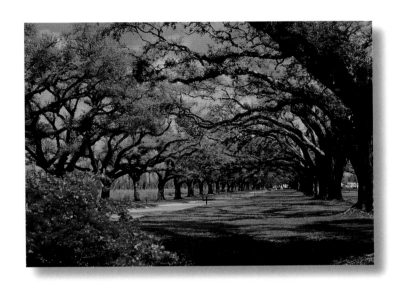

SOUTH CAROLINA

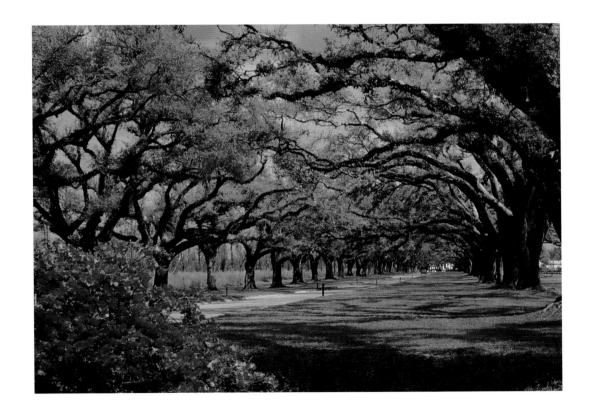

whitecap

Text by Helen Stortini
Edited by Mike Chilton
Photo editing by Helen Stortini
Proofread by Viola Funk
Cover and interior design by Steve Penner
Typeset by Helen Stortini and Diane Yee
Front cover photo of Boone Hall Plantation by Everett C. Johnson / Folio, Inc.
Back cover photo of Battery Street, Charleston by Paul Franklin

Printed and bound in China by 1010 Printing Asia Ltd.

Library and Archives Canada Cataloguing in Publication

Stortini, Helen, 1976–
 South Carolina / Helen Stortini.

 (America series)
 ISBN 1-55285-725-5
 ISBN 978-1-55285-725-0

 1. South Carolina—Pictorial works. I. Title. II. Series.

F270.S76 2005 **975.7'044'0222** **C2005-903562-5**

The publisher acknowledges the financial support of the Government of Canada through the Canada
Book Fund (CBF) and the Province of British Columbia through the Book Publishing Tax Credit.

**For more information on the America series and other titles by
Whitecap Books, please visit our website at www.whitecap.ca.**

Majestic live oaks line the winding dirt road of a cotton plantation. Waves wash onto palmetto-dotted sandy beaches. Mist shrouds the valleys of the rolling Blue Mountains. These are a few of the stunning vistas found in South Carolina.

It's difficult to believe that anything could disturb South Carolina's natural serenity, but these idyllic settings once formed the backdrop of the state's turbulent past. Restored homes, plantation grounds, and historic sites tell the story of the state's violent beginnings. One of the 13 states that rebelled against British rule, South Carolina saw more battles than any other state during the American Revolution. Many historians consider the battles of Kings Mountain and Cowpens to be Revolution turning points.

Rice, indigo, and cotton turned South Carolina into a thriving economic power, making it home to the richest plantation owners in the United States. But the state's economic success came at no small price: South Carolina had the country's largest number of African-American slaves. Today, restored plantation grounds pay tribute to the hardships of these exploited workers.

South Carolina further guaranteed its place in the history books during the Civil War. The state was the first to secede from the Union to found the Confederate States of America, and the first shots of the Civil War were fired from Charleston Harbor on April 12, 1861. Today, historical reenactments of the Civil War's most infamous battles serve as a reminder of this violent past.

In spite of its tumultuous history, South Carolina has preserved its southern charm. While sipping a thirst-quenching glass of iced tea in the cool shade of a plantation house's veranda and enjoying the beautiful surroundings, visitors can learn about some of the nation's most important historical events.

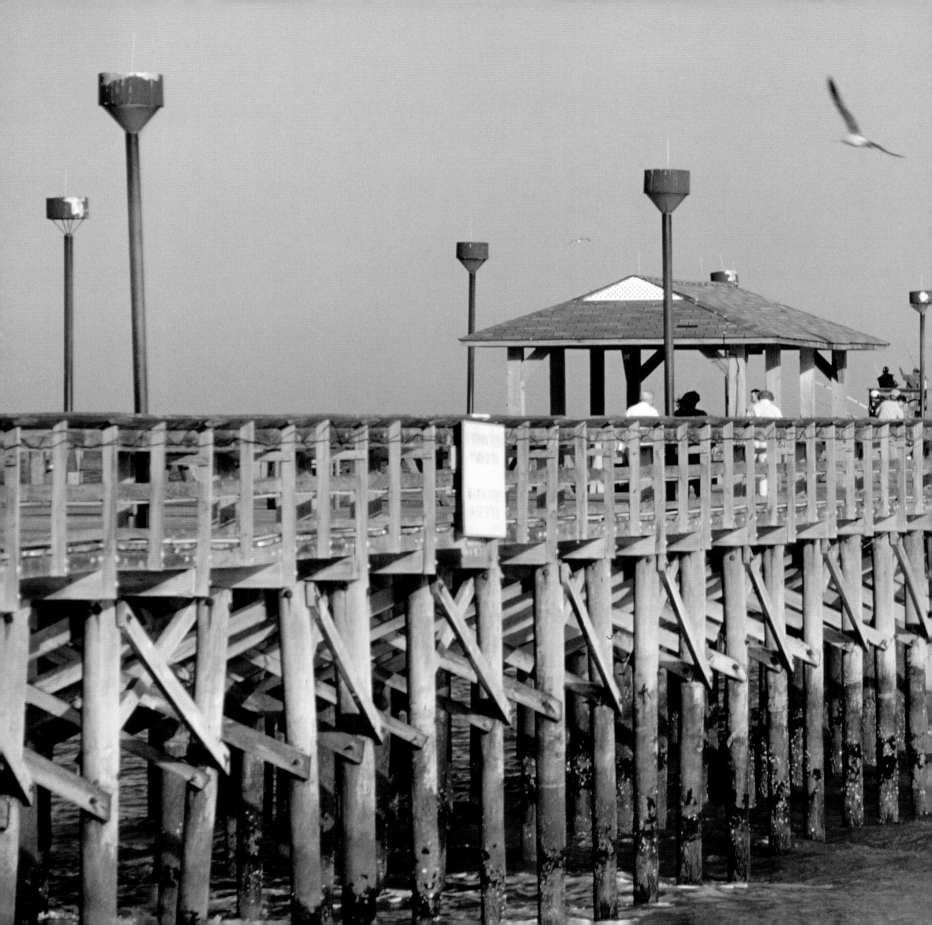

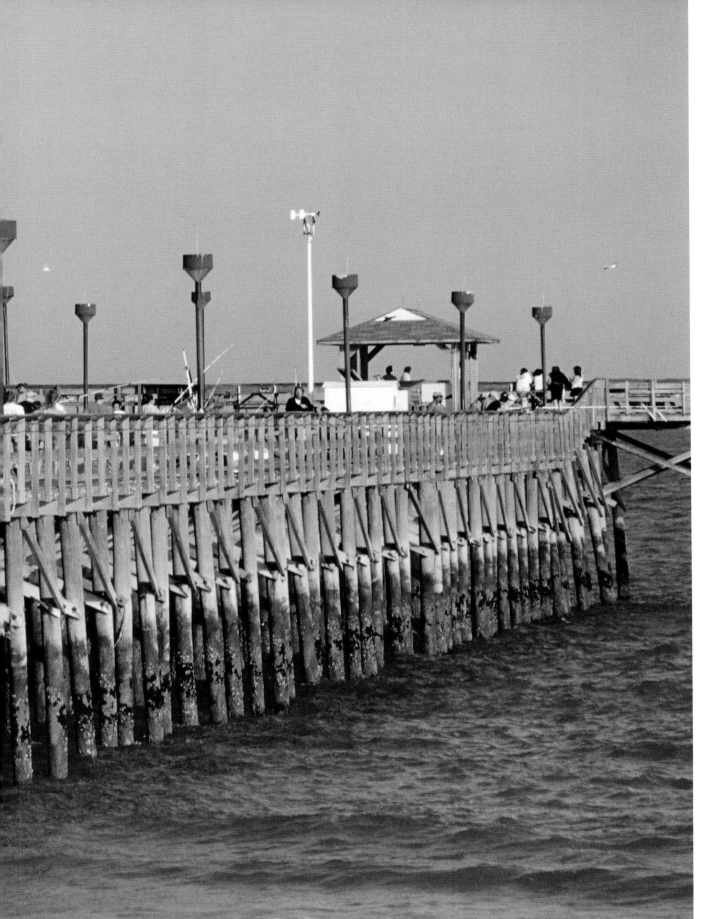

Located on the Grand Strand—a 60-mile crescent beach on South Carolina's northern coast—Myrtle Beach is home to about 30,000 residents. Each year, millions of tourists from around the world visit the pristine natural setting of what to many is "America's No. 1 Family Beach."

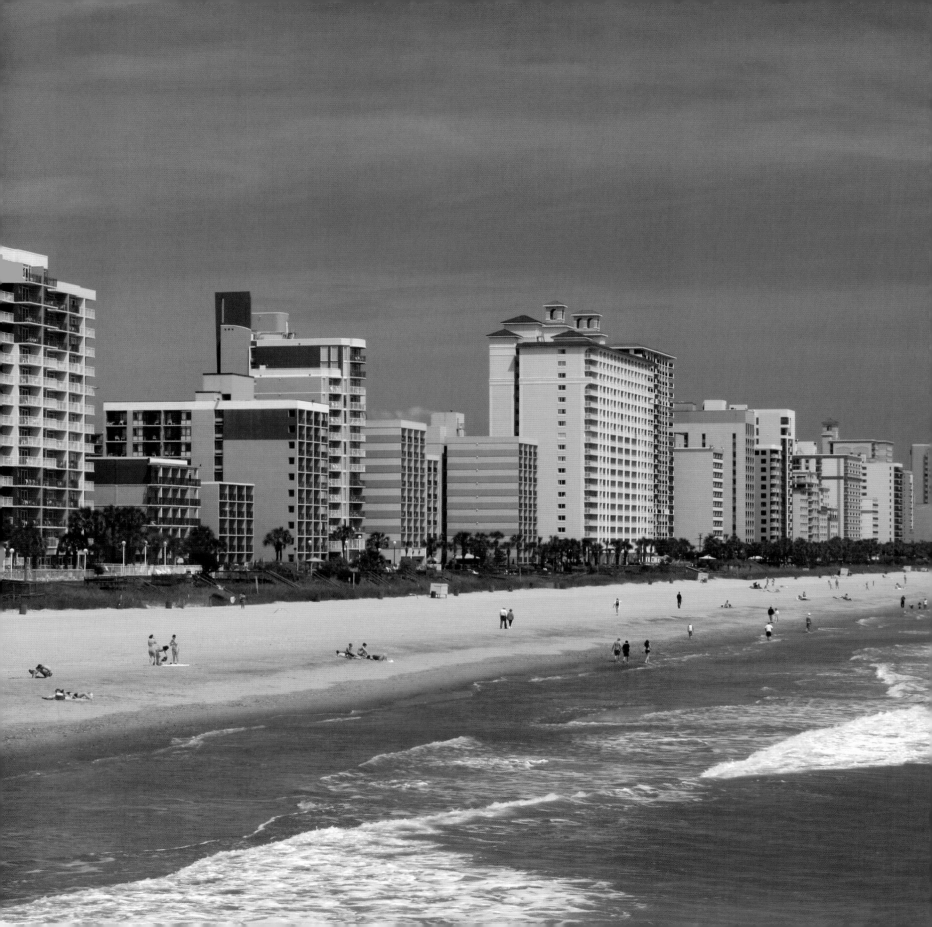

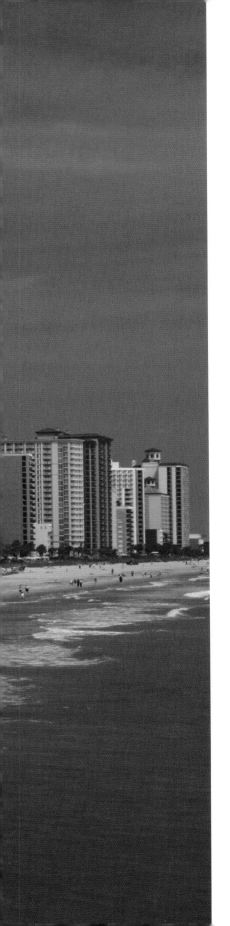

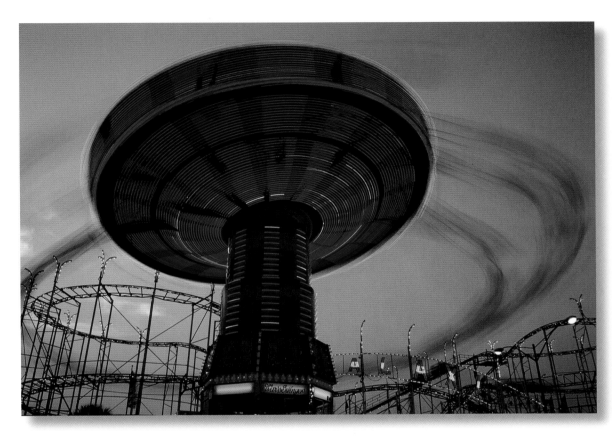

Located on 11 acres next to the sea, the Myrtle Beach Pavilion has entertained families for more than half a century. Visitors can choose from over 40 different rides and attractions.

Although there were initially few accommodations available, vacationers have been drawn to Myrtle Beach since the late 1800s. Today, this beach getaway offers more than 60,000 lodging units and over 100 golf courses.

Mrytle Beach and the Grand Strand are home to some of the best golf courses in the US. Designed to protect natural habitat and wildlife while also being challenging and beautiful, many have been created by world-famous golf legends, including Arnold Palmer and Jack Nicklaus.

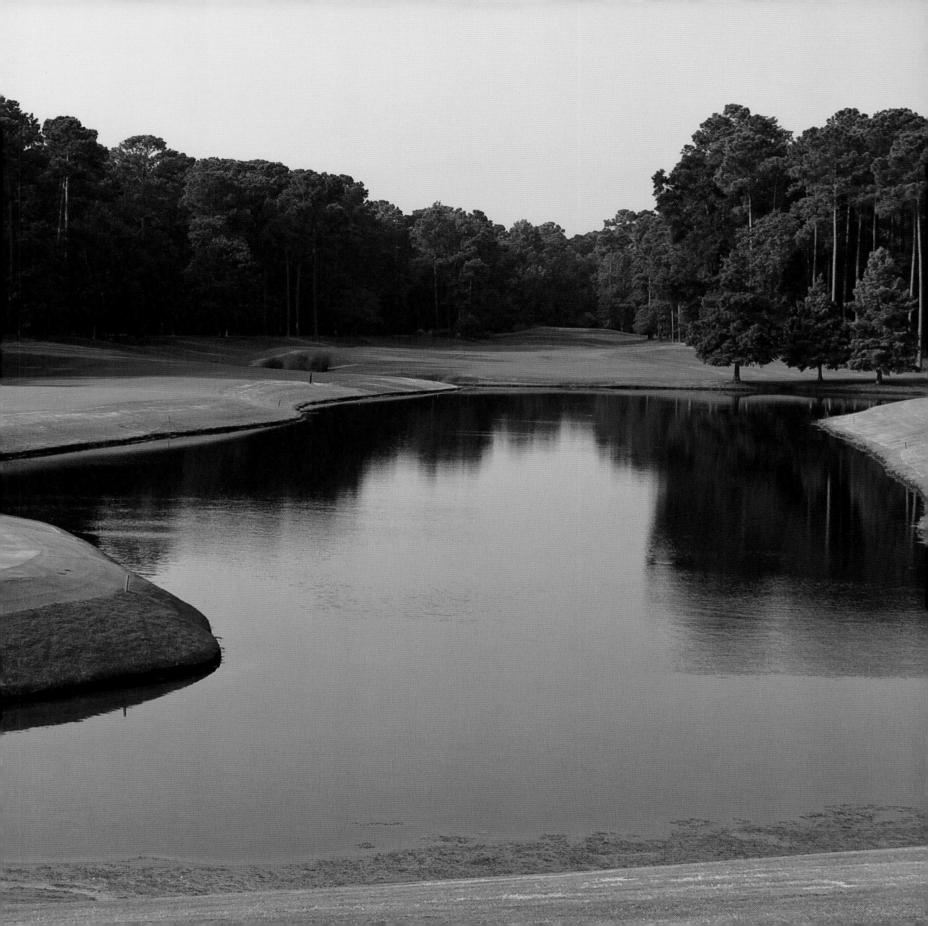

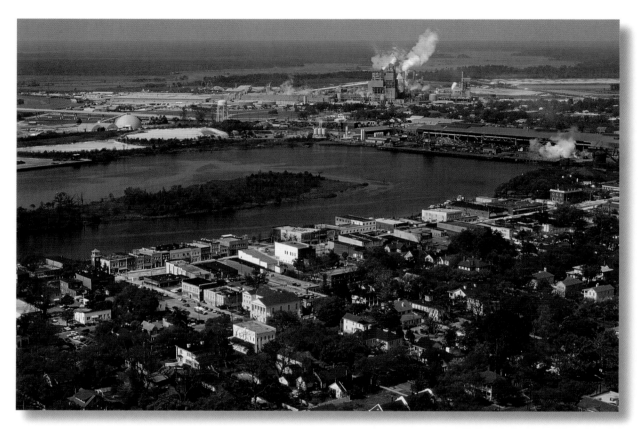

As the state's third-oldest city, Georgetown—formerly a bustling seaport—dates back to 1729. Tall-masted ships brought goods from Europe and set sail again, loaded with products from South Carolina's Lowcountry, which generally encompasses the low-lying coastal regions south of the Grand Strand.

Murrells Inlet is the state's seafood capital. Here, visitors can sample the delicious fresh seafood at one of the many restaurants or catch their own dinner aboard a fishing charter.

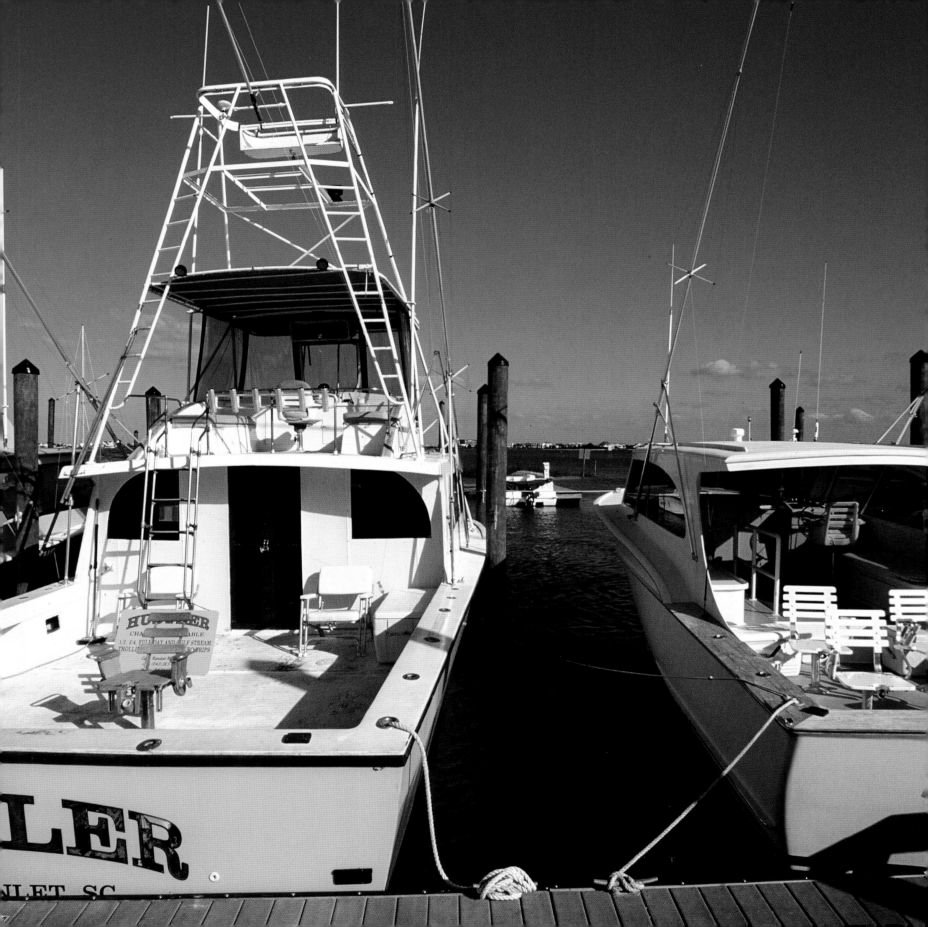

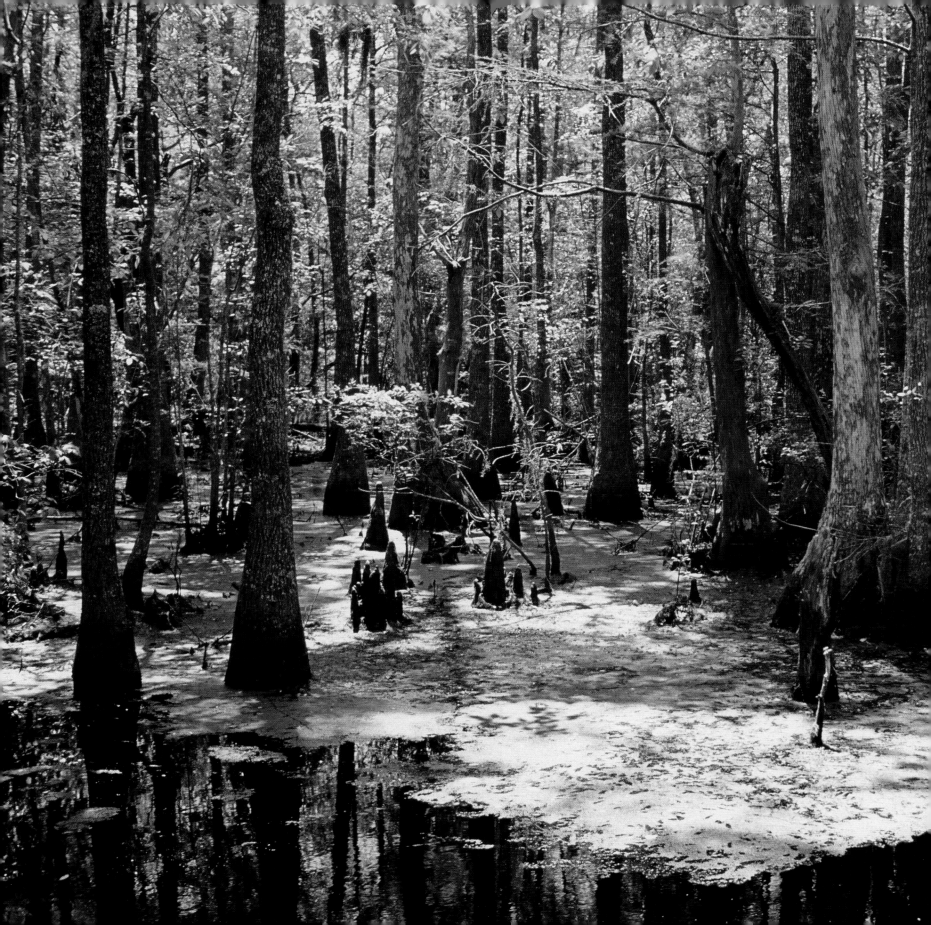

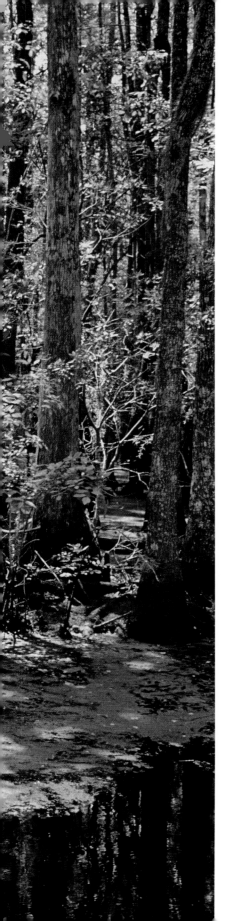

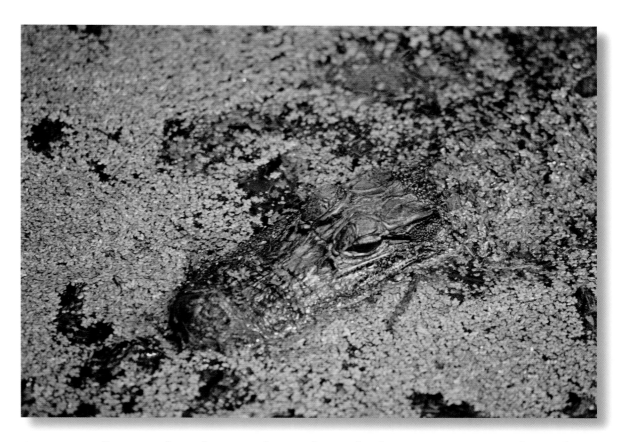

American alligators found in South Carolina's freshwater swamps and marshes can reach up to 14 feet in length. Until 1970, about 10 million alligators were killed for their skins. Since it was listed as a threatened species under the Federal Endangered Species Act, its population has increased significantly.

Named after the Revolutionary War general, the Francis Marion National Forest was proclaimed a national forest in 1936, thanks to its array of wildlife and bald cypress and water tupelo trees.

15

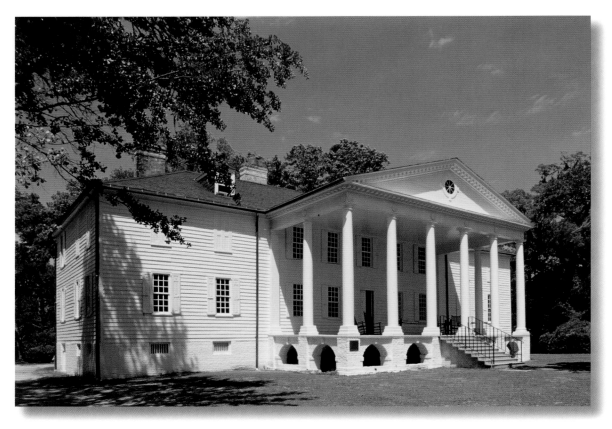

Plantation houses are as much a part of South Carolina's scenery as the palmettos, live oaks, and Spanish moss. Once a bustling rice plantation, the Hampton Plantation is now a monument to enslaved African laborers, and offers tours of its Georgian-style mansion.

Imposing trunks and the sprawling, moss-covered limbs of live oaks line the plantation grounds like ancient sentinels. These majestic trees live up to 300 years.

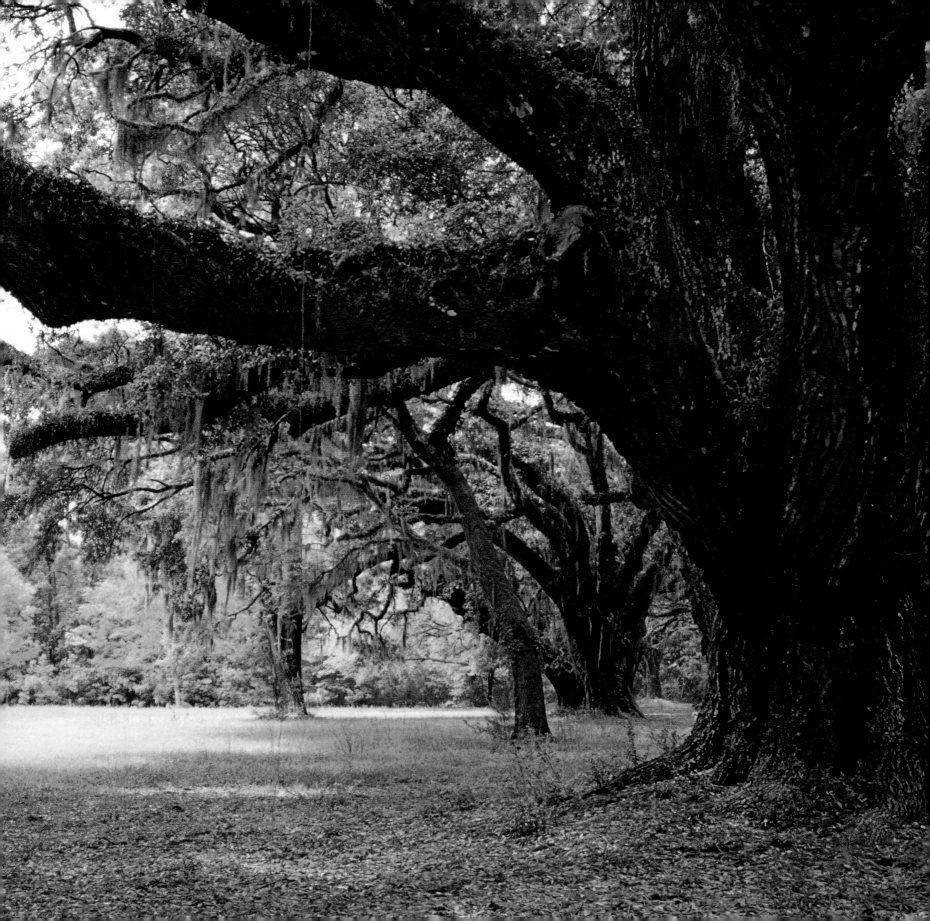

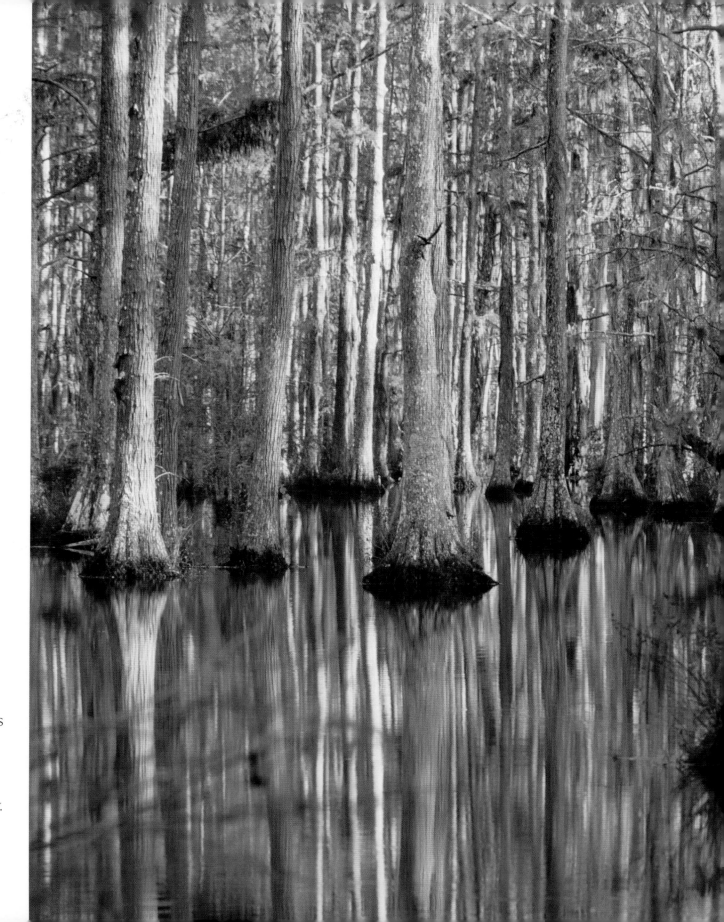

Visitors can explore the majestic swamps of Cypress Gardens on a flat-bottom boat. Considered one of the most beautiful gardens in the world, it also offers a butterfly house, an aquarium, a crocodile isle, and an aviary.

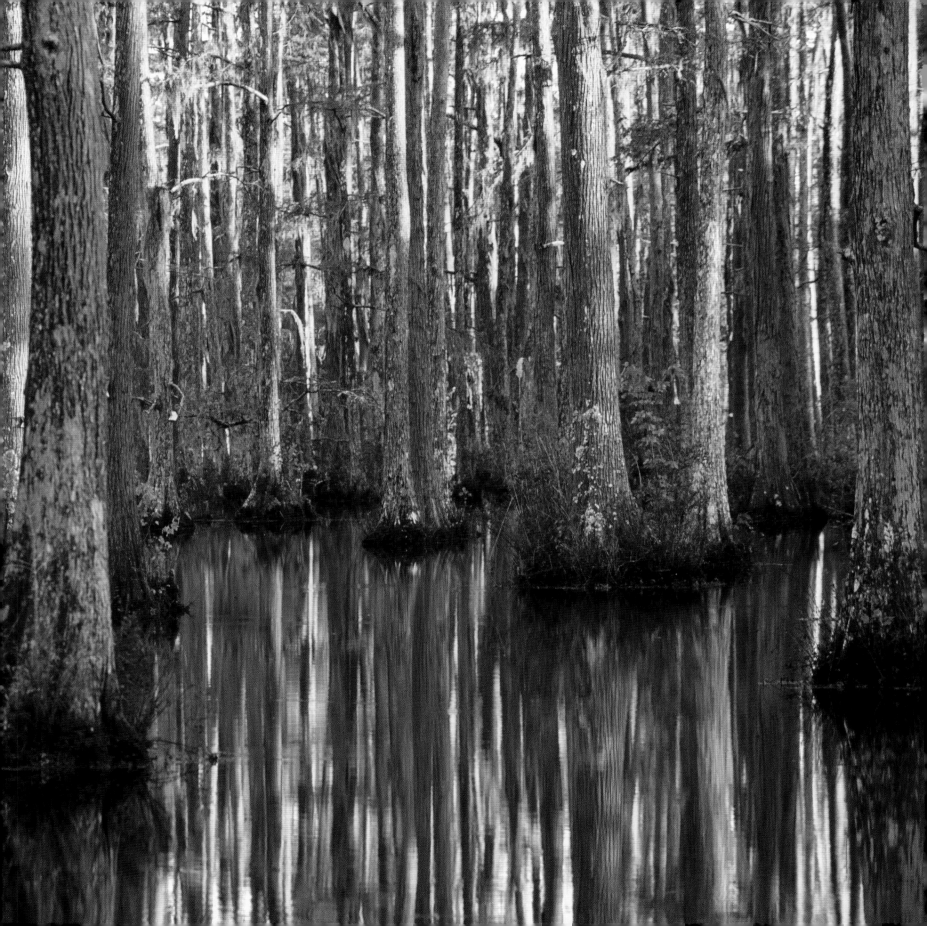

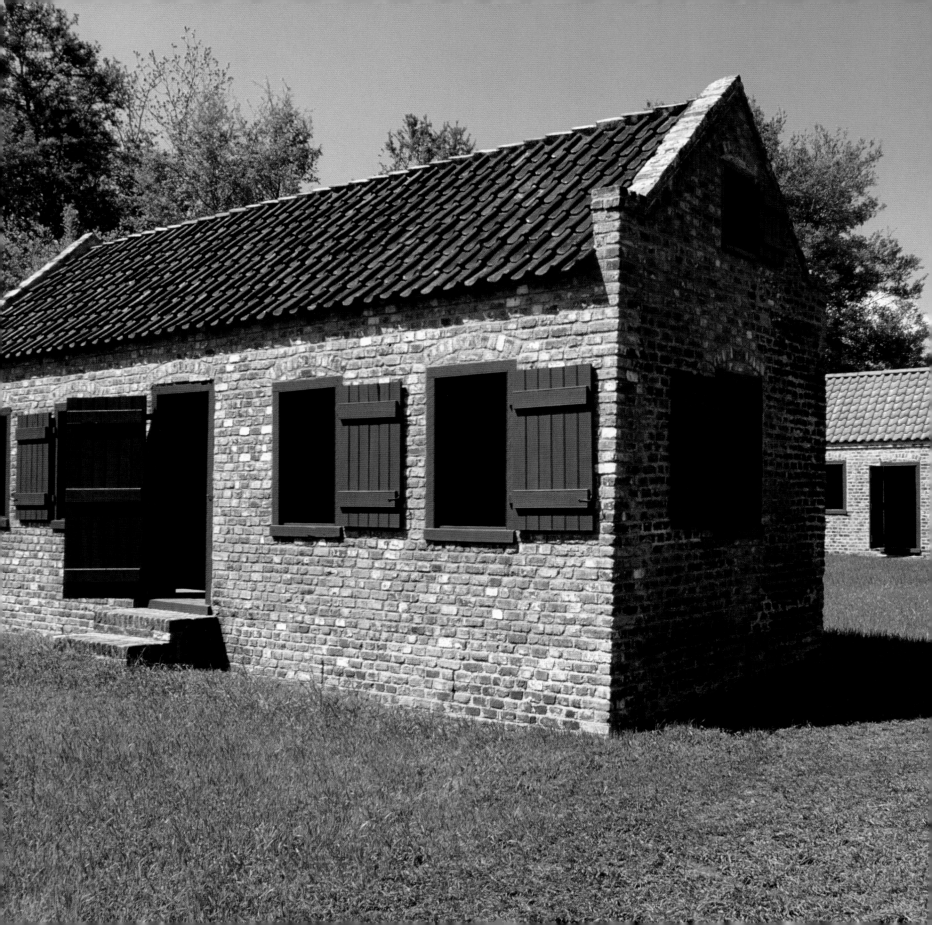

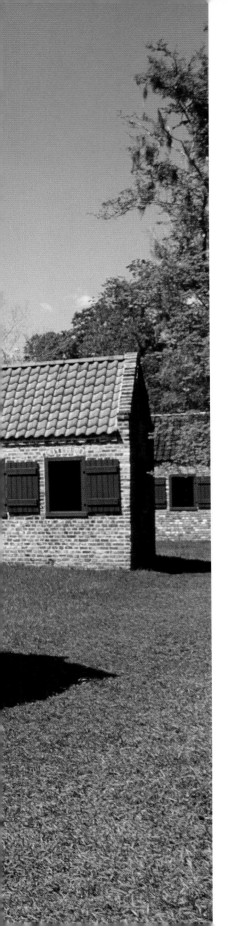

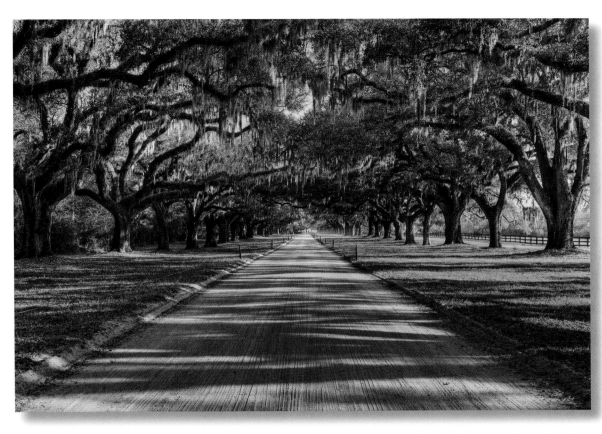

The scenic surroundings of Boone Hall Plantation have been featured in both *Gone with the Wind* and the miniseries "North and South."

Boone Hall is one of America's oldest working plantations, growing crops such as cotton for over 320 years. Nine original slave cabins from the 1800s exhibit artifacts and educational displays about what life during this time was like.

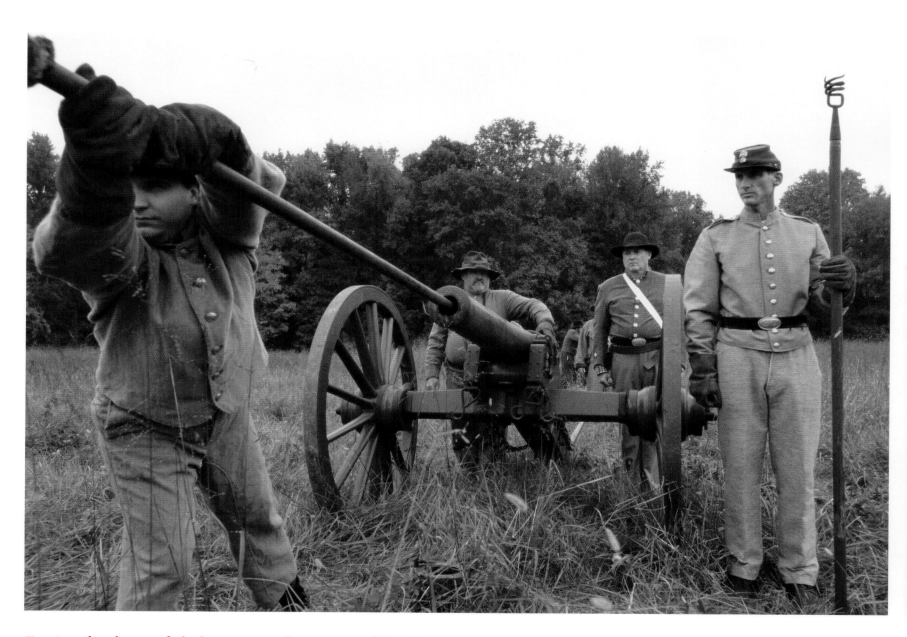

Fearing the threat of abolitionists and a stronger federal government, South Carolina prompted the Civil War when it seceded from the Union on December 20, 1860. Actors, such as these shown here, recreate historic battles from this bloody four-year war.

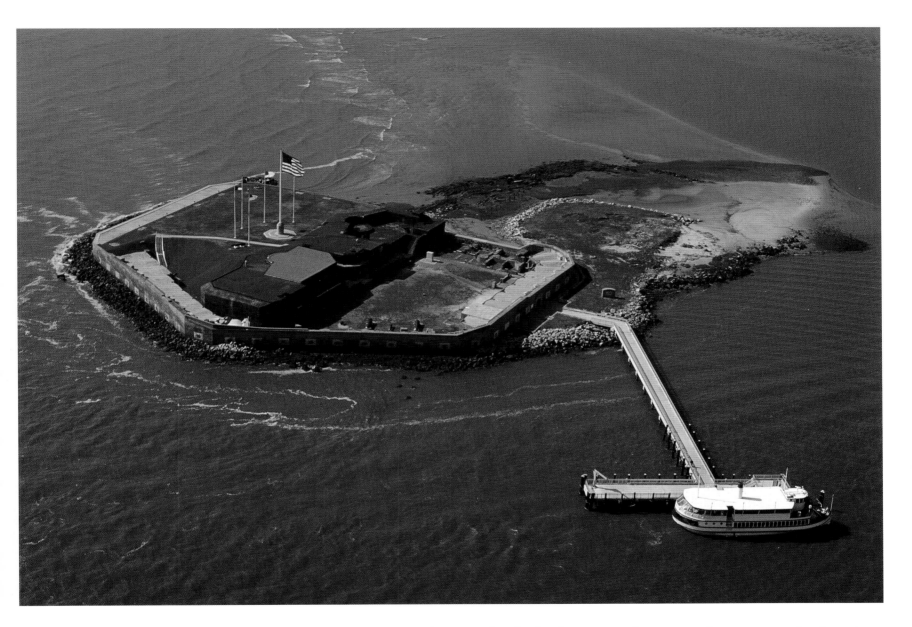

Situated at the mouth of Charleston Harbor, Fort Sumter was the location of one of the most defining moments in the nation's history. On April 12, 1861, the first shots of the Civil War were fired from this man-made island. This historical spot is now a national monument.

Founded in 1670, Charleston is the state's oldest city. Rich with historic sites and iconic architecture, the city is the destination of choice for nearly four million people a year. The well-maintained antebellum mansions that overlook Charleston Harbor make visitors think they've been transported back in time.

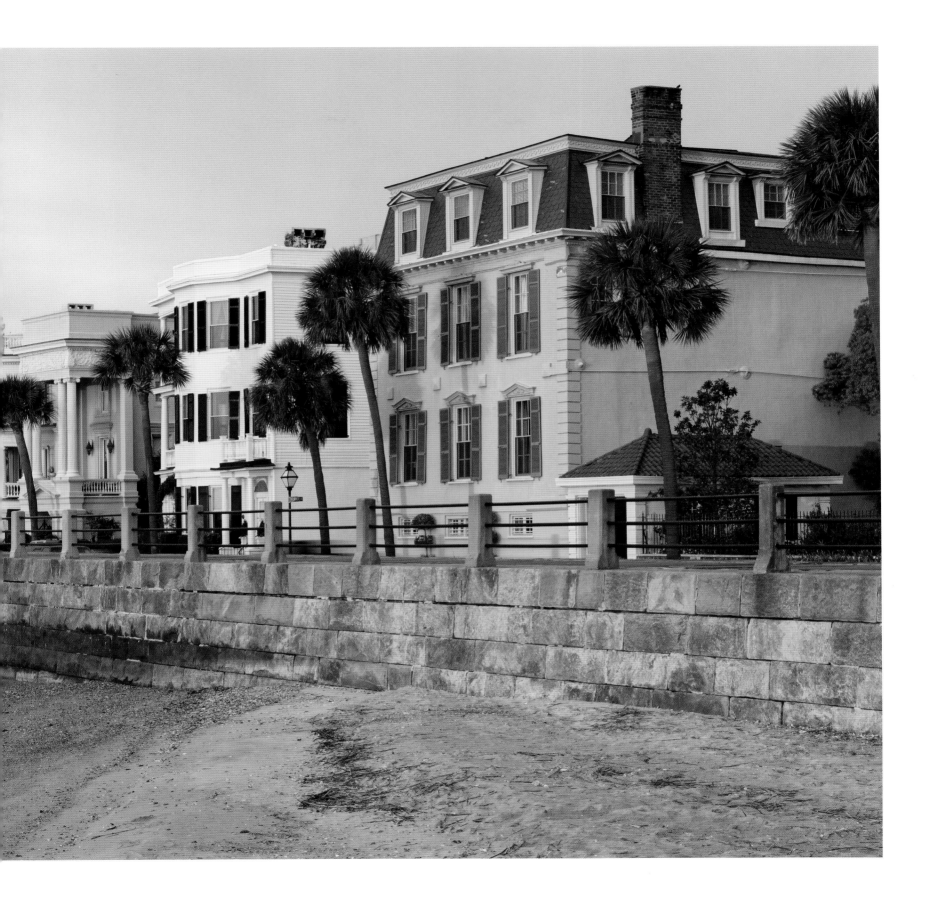

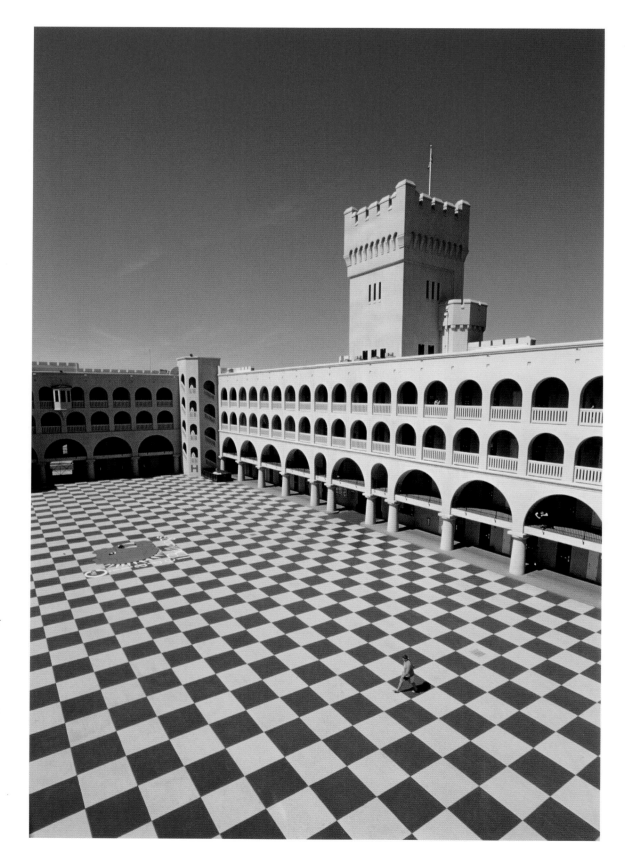

The Citadel—a coeducational military college—offers the largest military college program outside of the nation's service academies, boasting more than 1,900 students.

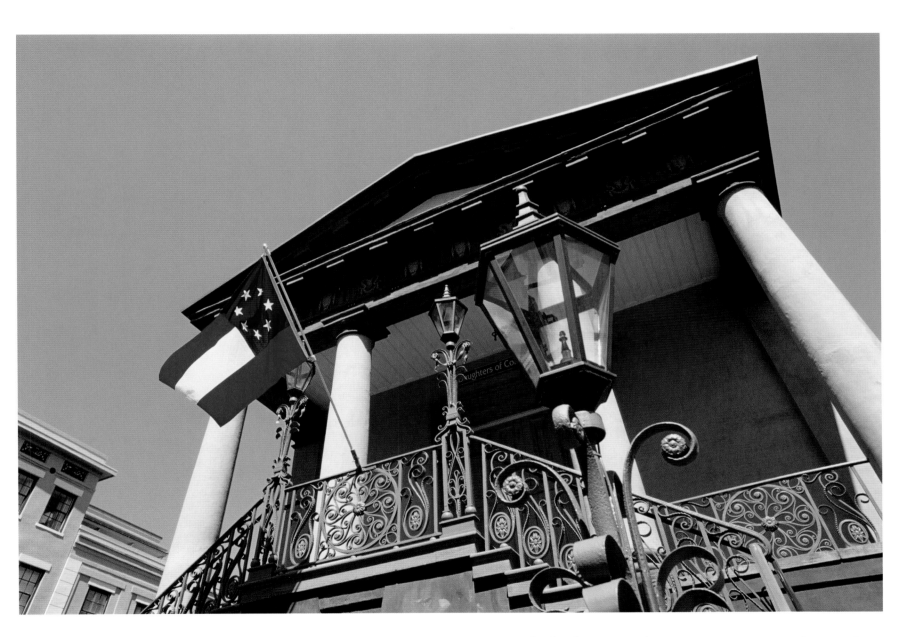

Once the commercial center of Charleston and a recruiting station during the Civil War, the Old City Market Hall is now a charming setting for many shops and restaurants.

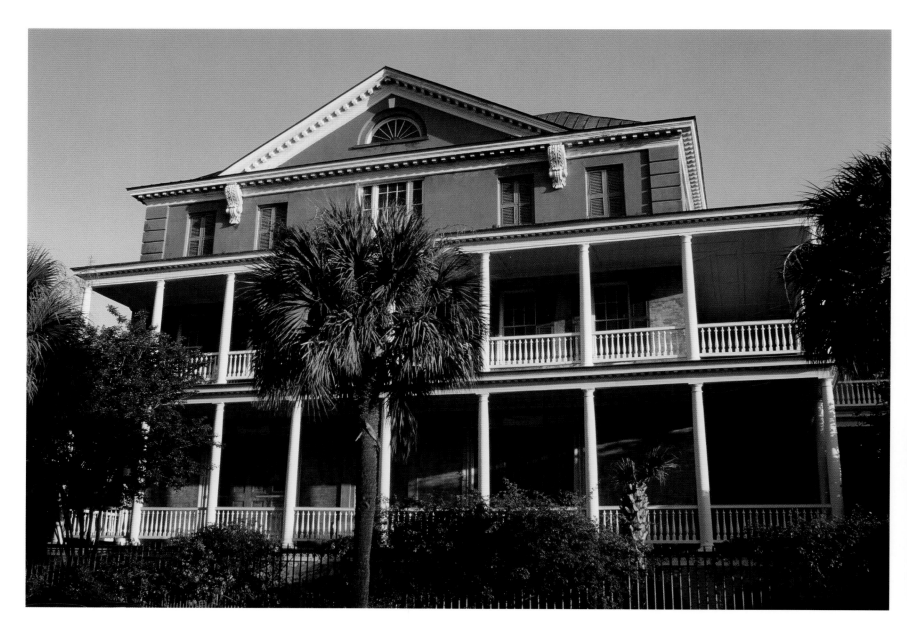

An excellent example of how Charleston's wealthy class thrived before the Civil War, the Aiken-Rhett House is lavishly furnished. The surrounding yard contains some of the nation's best-preserved examples of slaves' quarters, kitchens, privies, and cattle sheds.

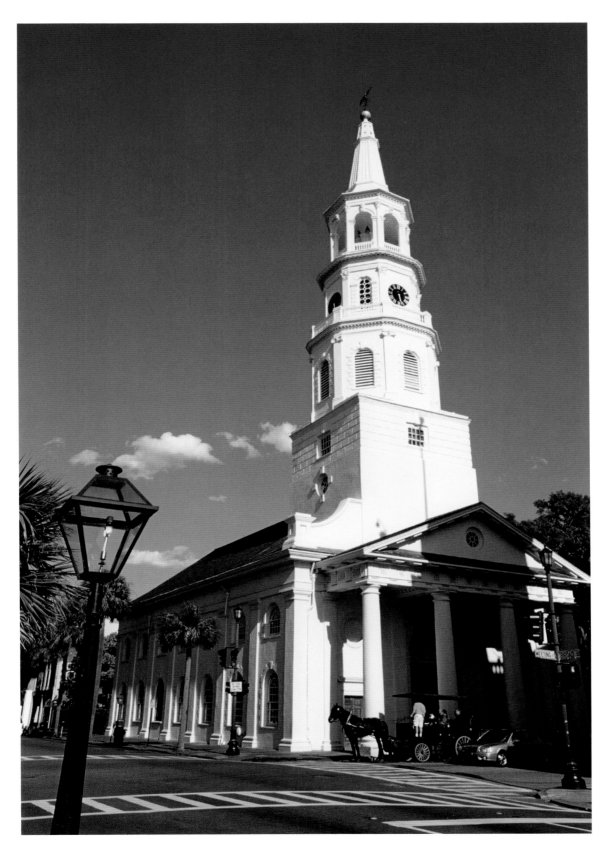

Standing on the site of the first Anglican Church south of Virginia, St. Michael's Church is Charleston's oldest church edifice.

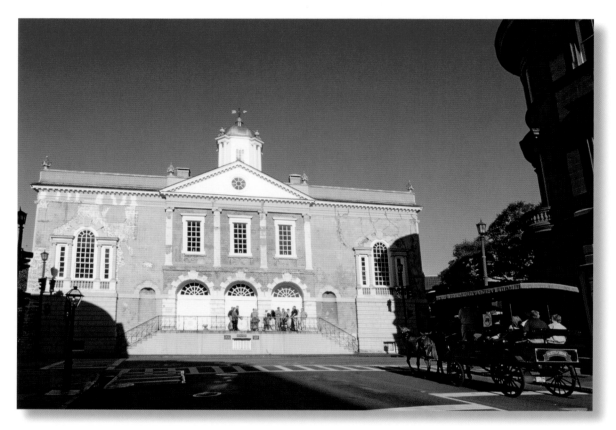

One of Charleston's most significant historic sites is the Old Exchange Building. Beneath it lies Provost Dungeon, which was a prison used by the British during the Revolutionary War.

On Charleston's southern tip is the Middleton Place House Museum. This 18th-century plantation is home to America's oldest landscaped gardens and the Middleton Oak—whose age is estimated at nearly 1,000 years.

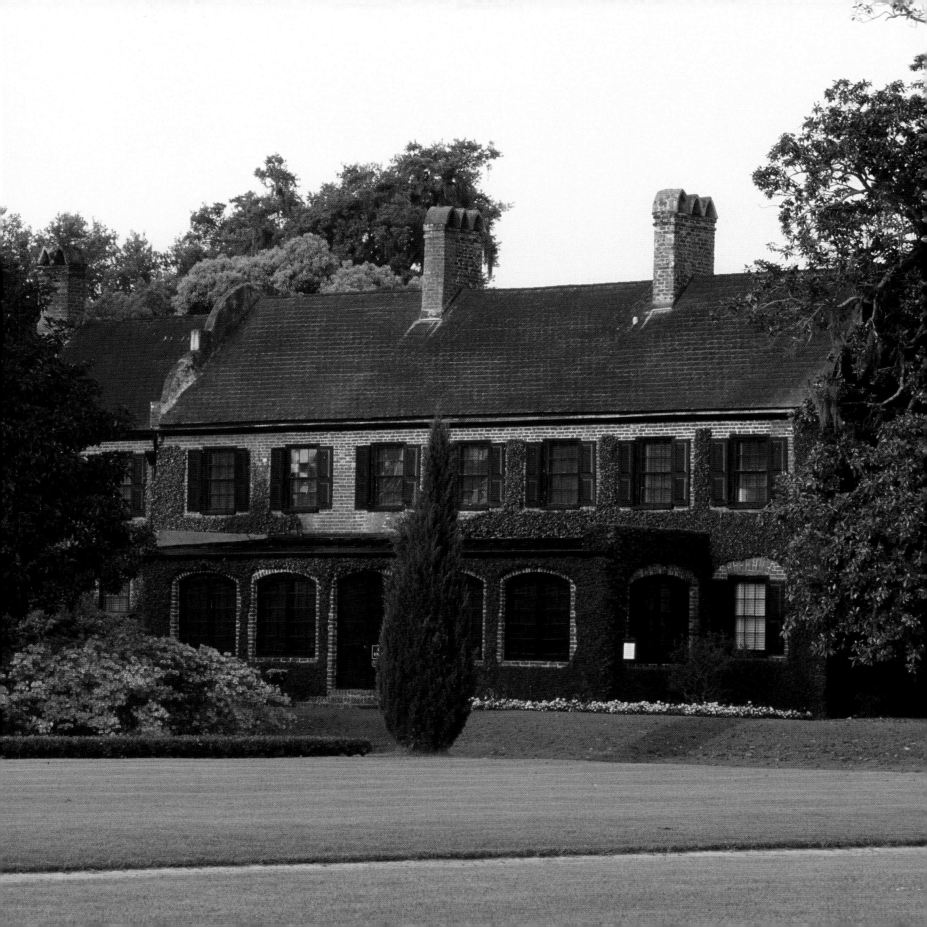

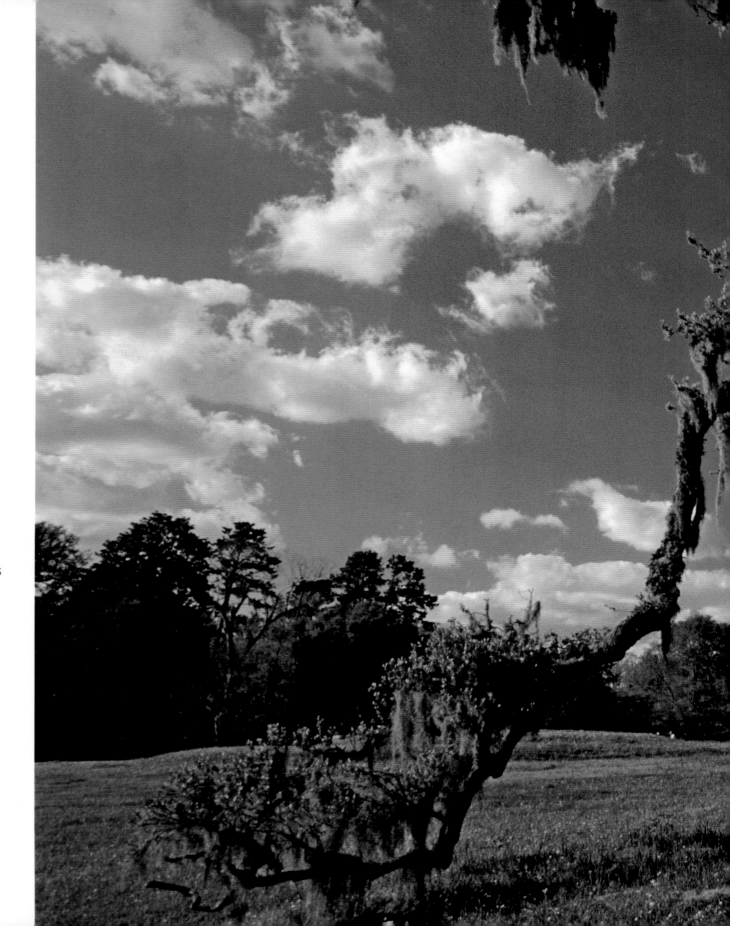

Built between 1738 and 1742, Drayton Hall is one of the nation's best examples of Georgian Palladian architecture. It's also the state's oldest plantation house open to the public. Visitors can wander through the original interior, which has never been wired for electricity or had plumbing installed.

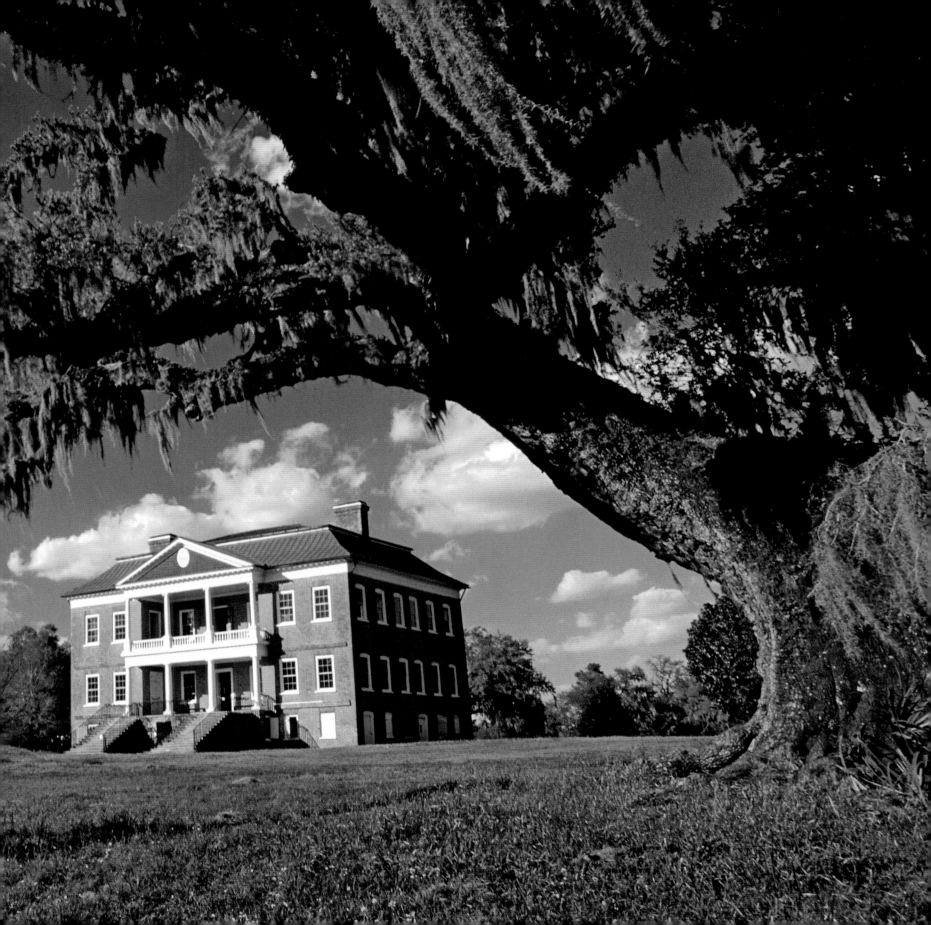

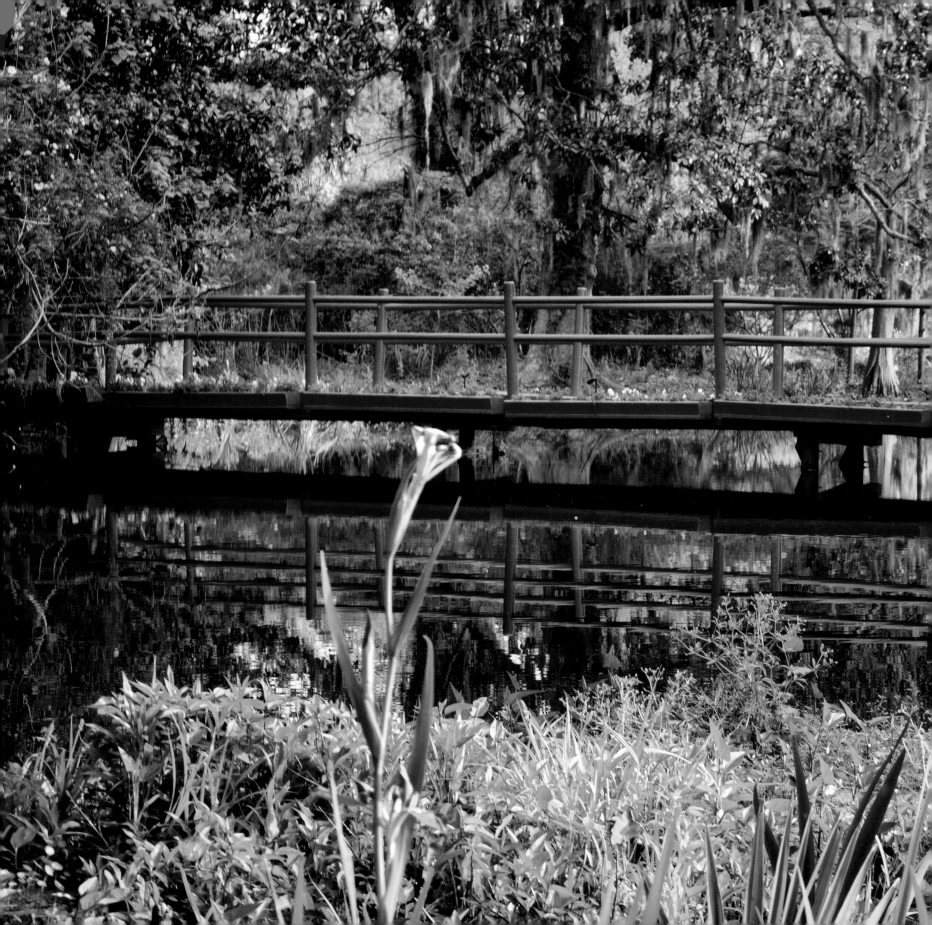

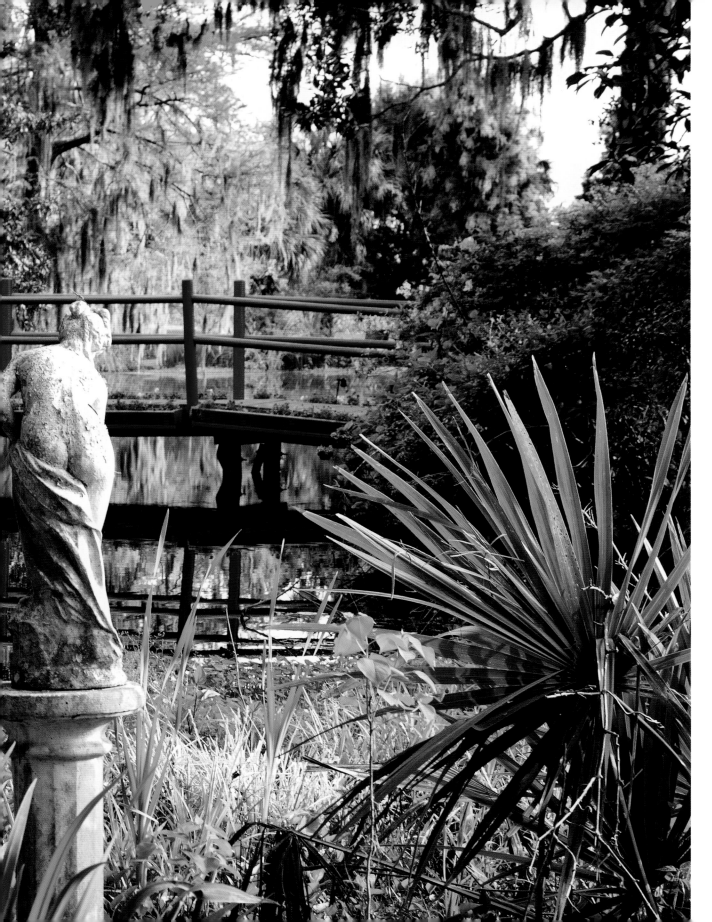

Time stands still on the 300-year-old Magnolia Plantation. Complete with oak-lined roads, a horticultural maze, and Barbados-style tropical gardens, this plantation epitomizes Southern hospitality and charm.

35

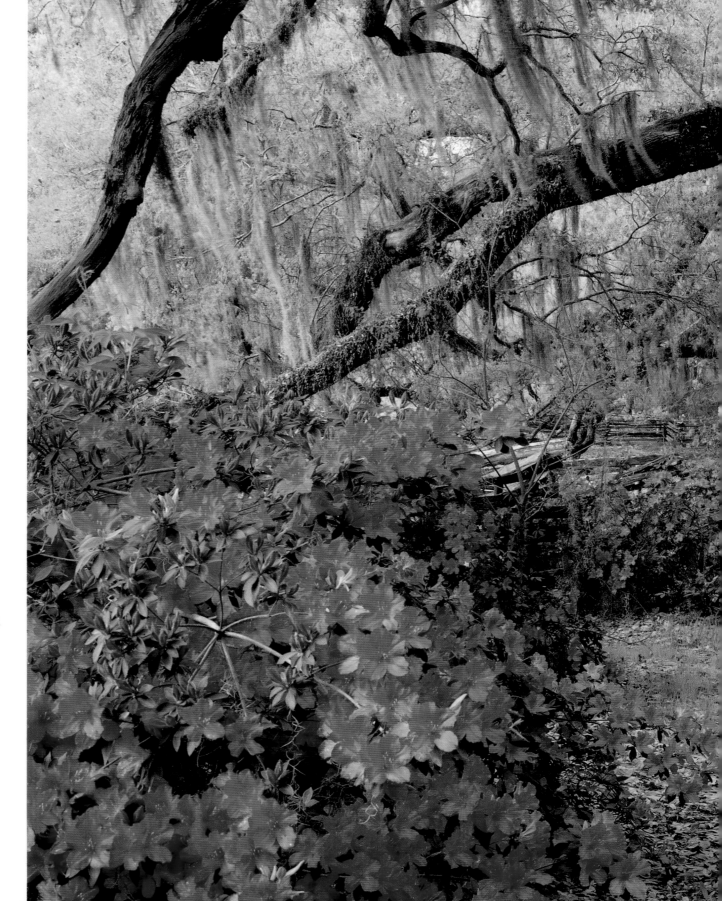

Founded in 1676 by the Drayton Family, Magnolia Plantation is the oldest public tourist site in South Carolina's Lowcountry, and the oldest public gardens in America. First opened to the public in 1870, thousands of beautiful flowers and plants thrive in its now-famous gardens.

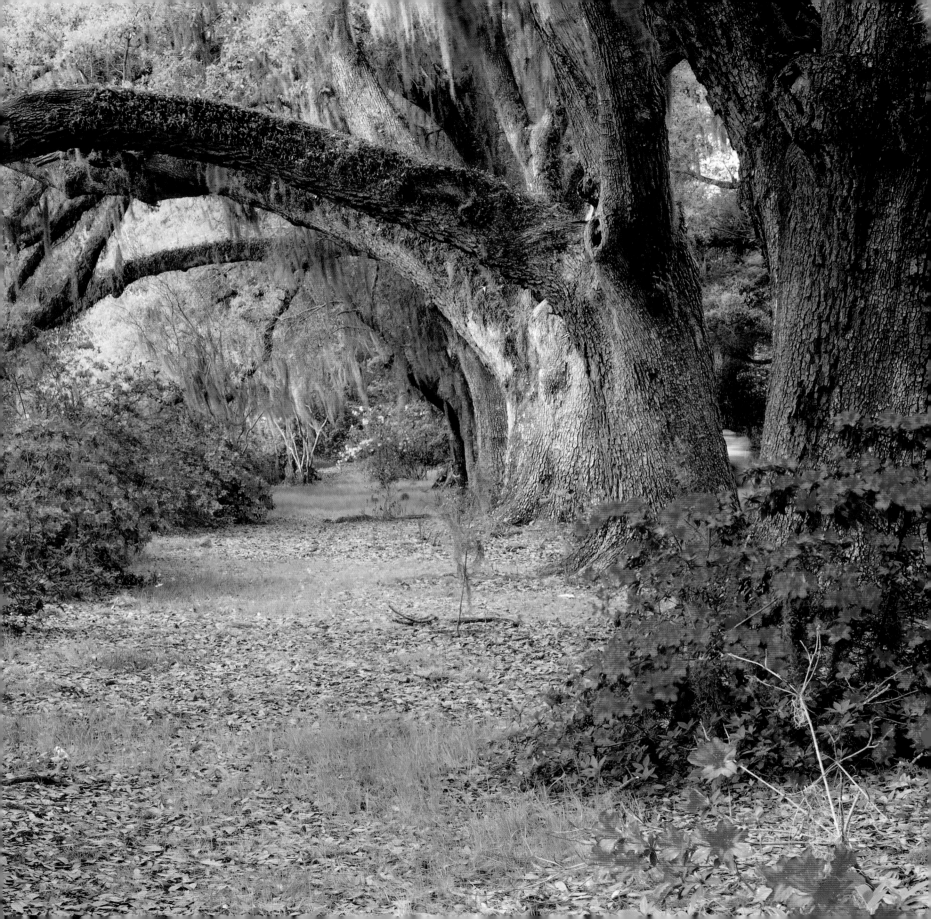

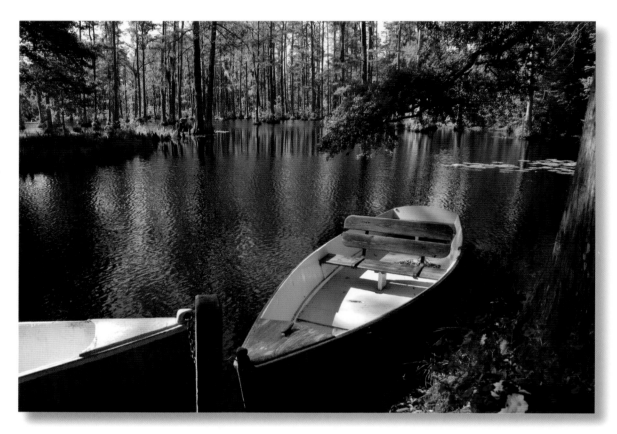

South Carolina experiences a humid, subtropical climate. Summers are long and hot, with temperatures reaching as high as 90 degrees. Winters are short and mild, with temperatures as low as 31 degrees.

Edisto Beach State Park was among several in South Carolina that were created during the Great Depression to help ease unemployment while addressing national conservation and recreation needs. Accommodations in the park include campgrounds on the palmetto-lined beach and in the maritime forest—with its live oaks, pristine marshlands, and some of the state's tallest palmettos.

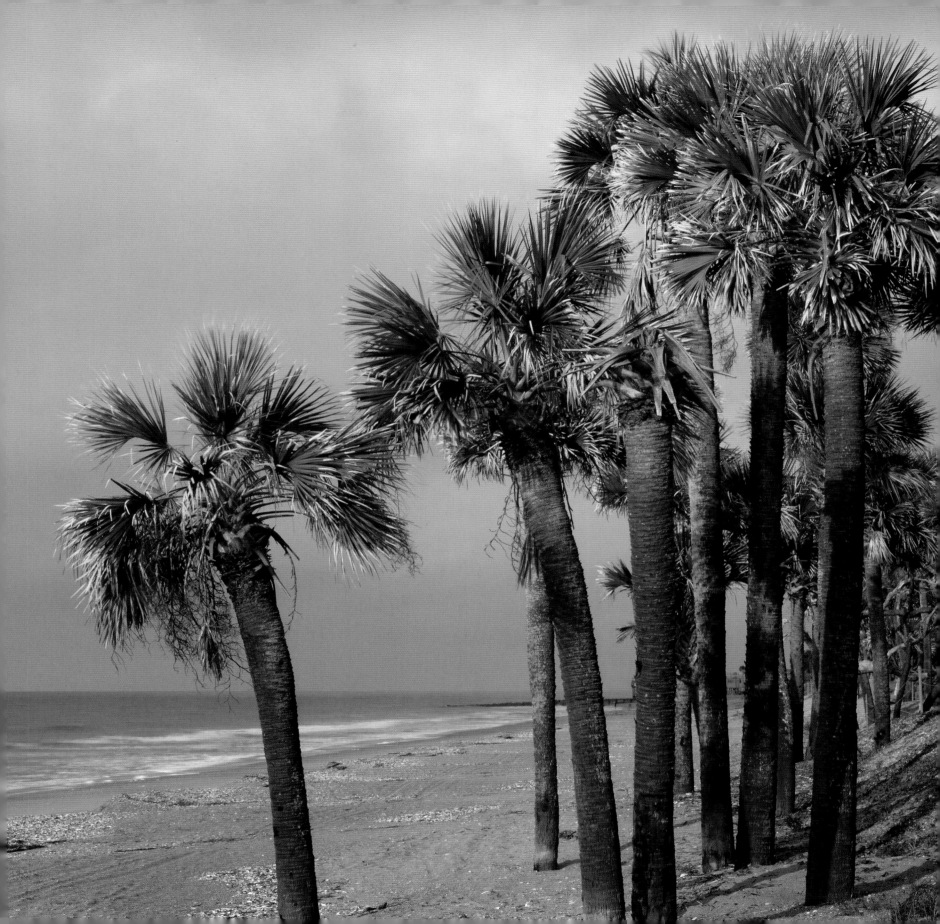

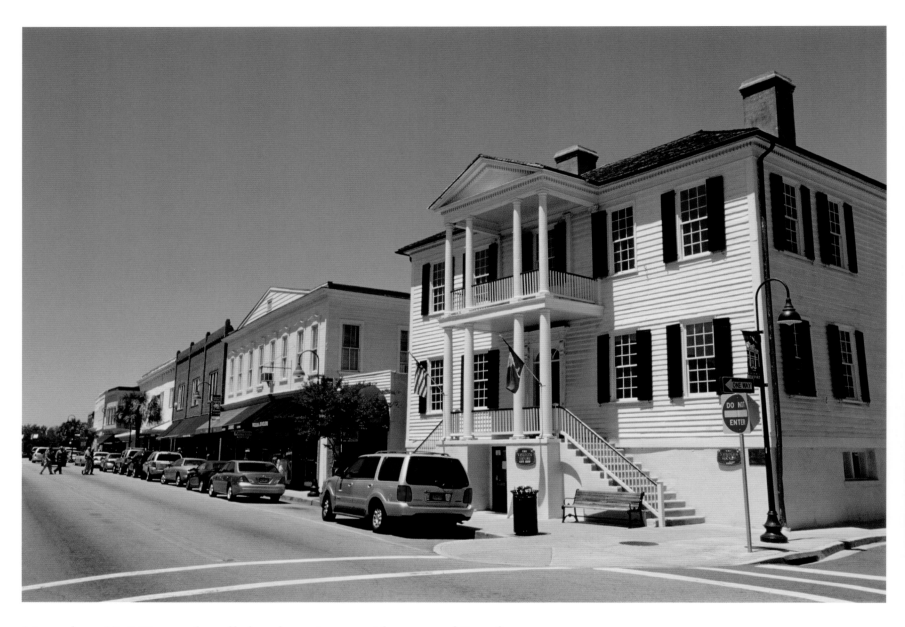

More than 12,000 people call the charming seaside town of Beaufort home. Founded by the Spanish in 1514, Beaufort is South Carolina's second-oldest city.

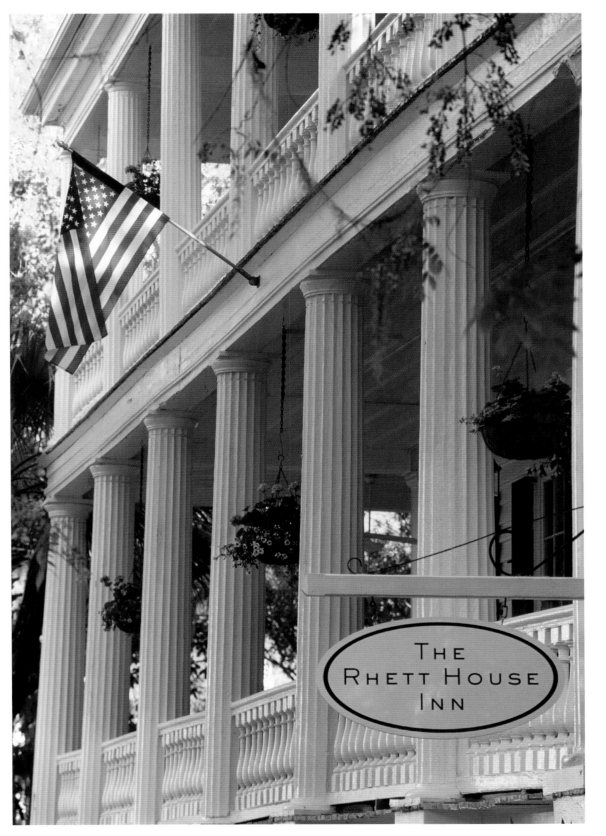

Beaufort boasts many beautifully maintained examples of 18th- and 19th-century architecture. The building shown here is a fine restoration showing a classic 19th century Southern antebellum structure.

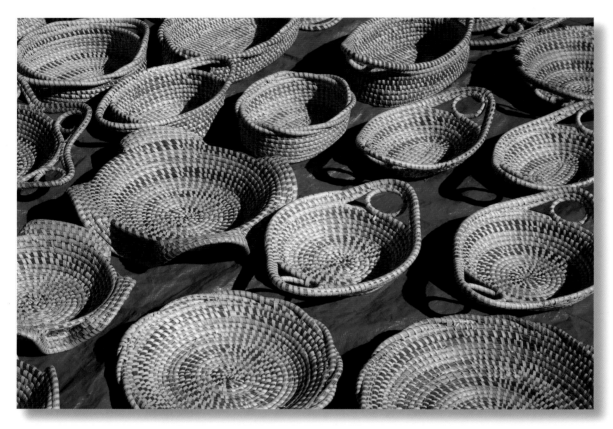

Sea-grass baskets, hand-woven by the Gullah people, are a popular tourist item in Beaufort. The Gullah are descendants of West African slaves who worked on plantations. Their communities on the islands near Beaufort have preserved much of Gullah culture for the past 300 years.

Hunting Island State Park comprises 5,000 acres of lush semi-tropical foliage and sandy beaches. The island—which is now a wildlife preserve—used to be a popular place to hunt deer and waterfowl.

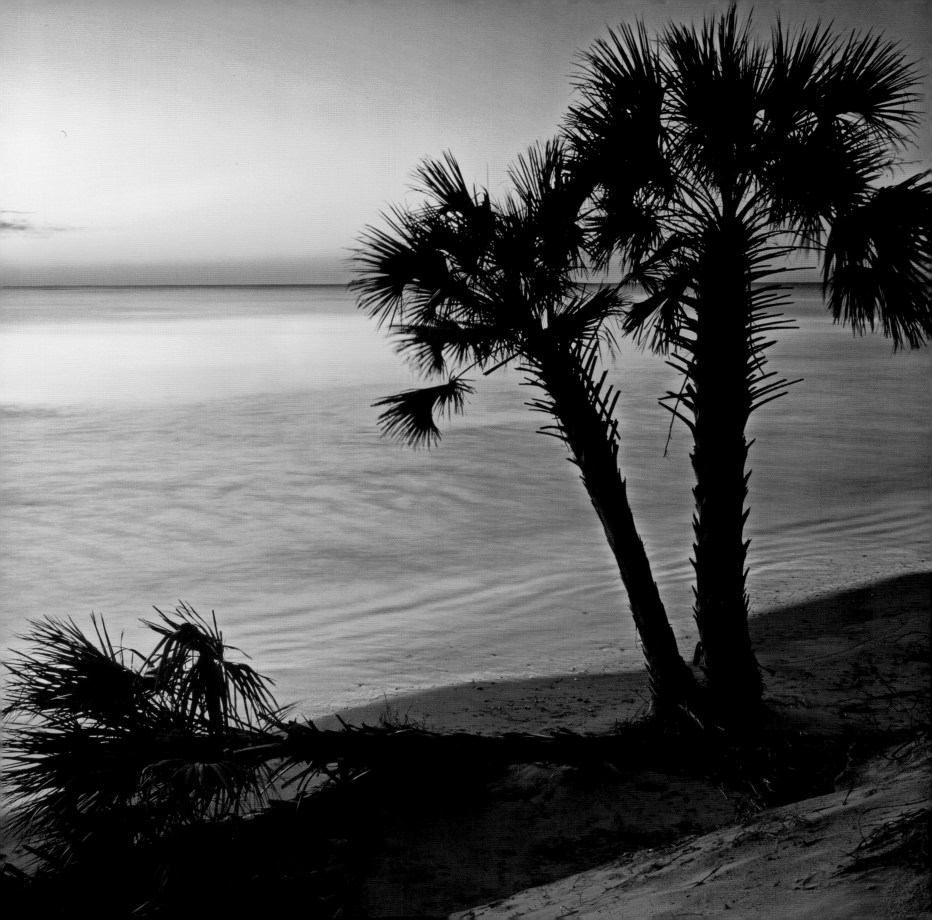

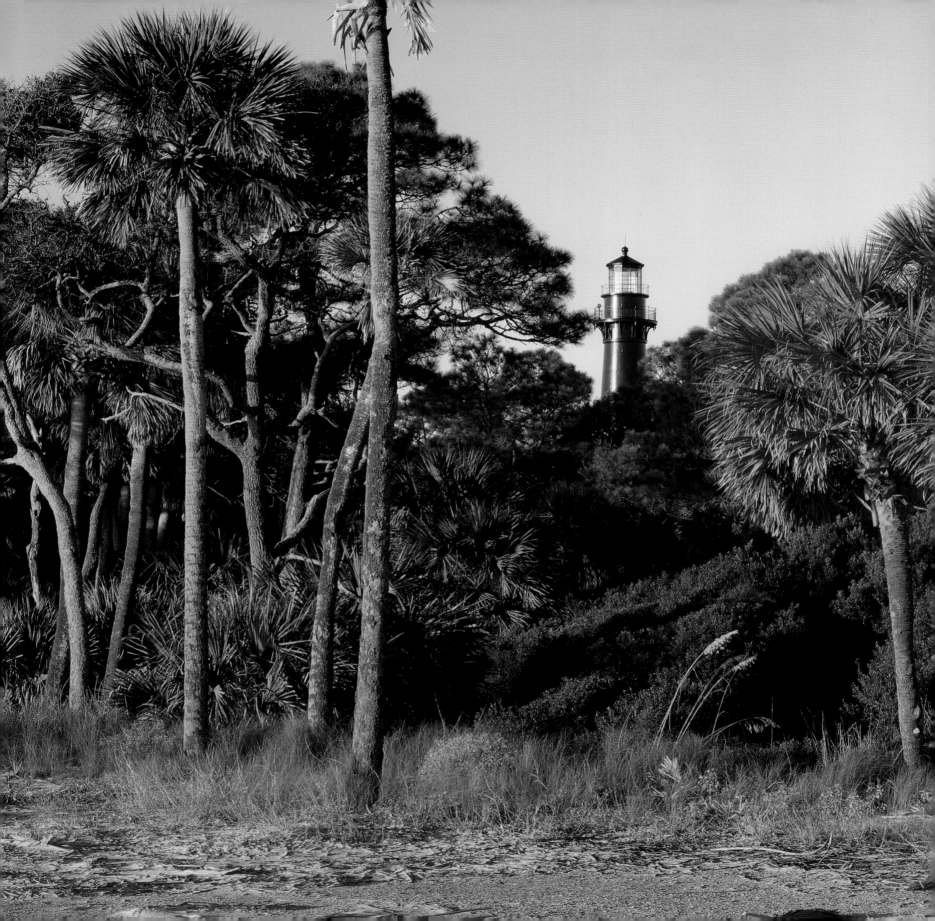

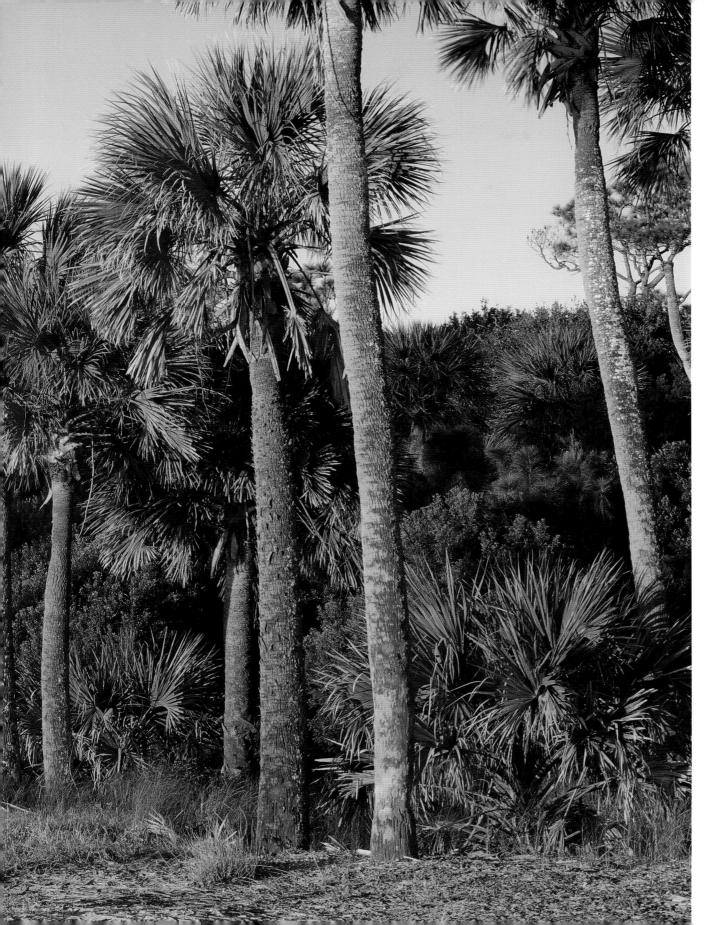

In addition to its naturally-occurring flora and fauna, Hunting Island State Park is home to the state's only publicly accessible historic lighthouse. Dating from the 1870s, it rises over 130 feet, giving visitors sweeping views of the area's marshlands and the Atlantic Ocean.

OVERLEAF—
Hilton Head Island—a foot-shaped barrier island located off the state's southernmost reaches—is home to 31,000 residents. The island is considered one of the finest resort communities in the country and hosts more than 2.5 million visitors each year.

45

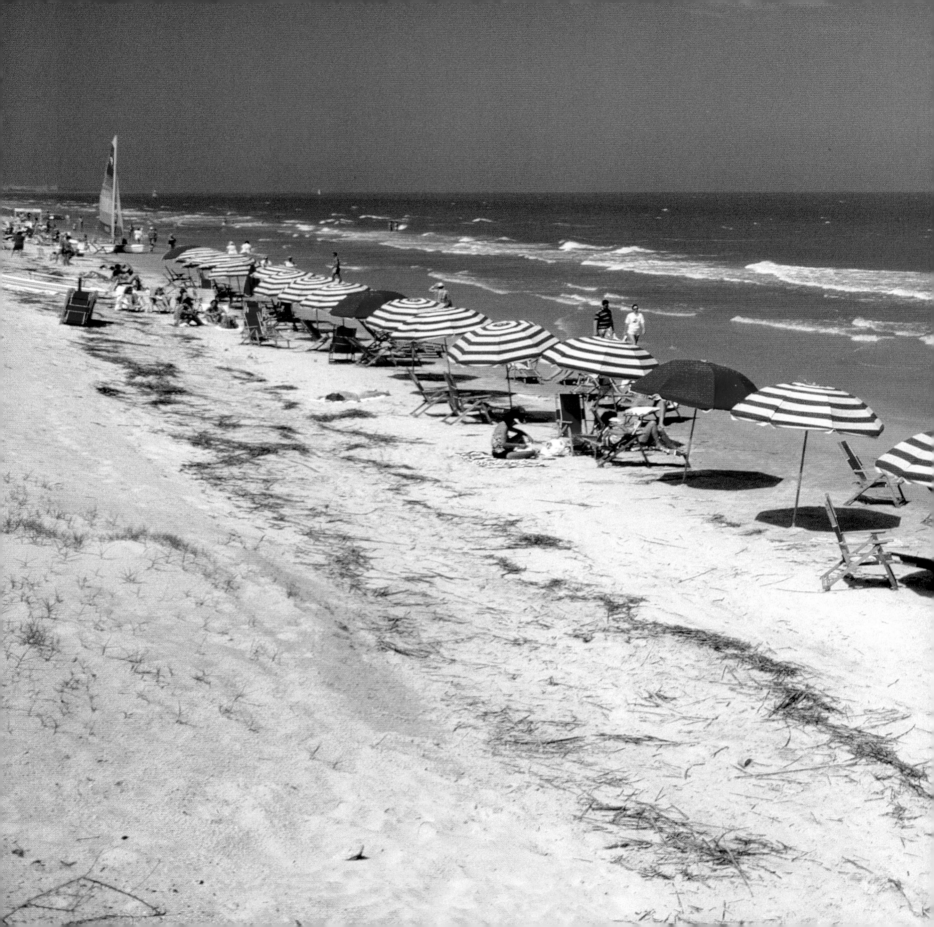

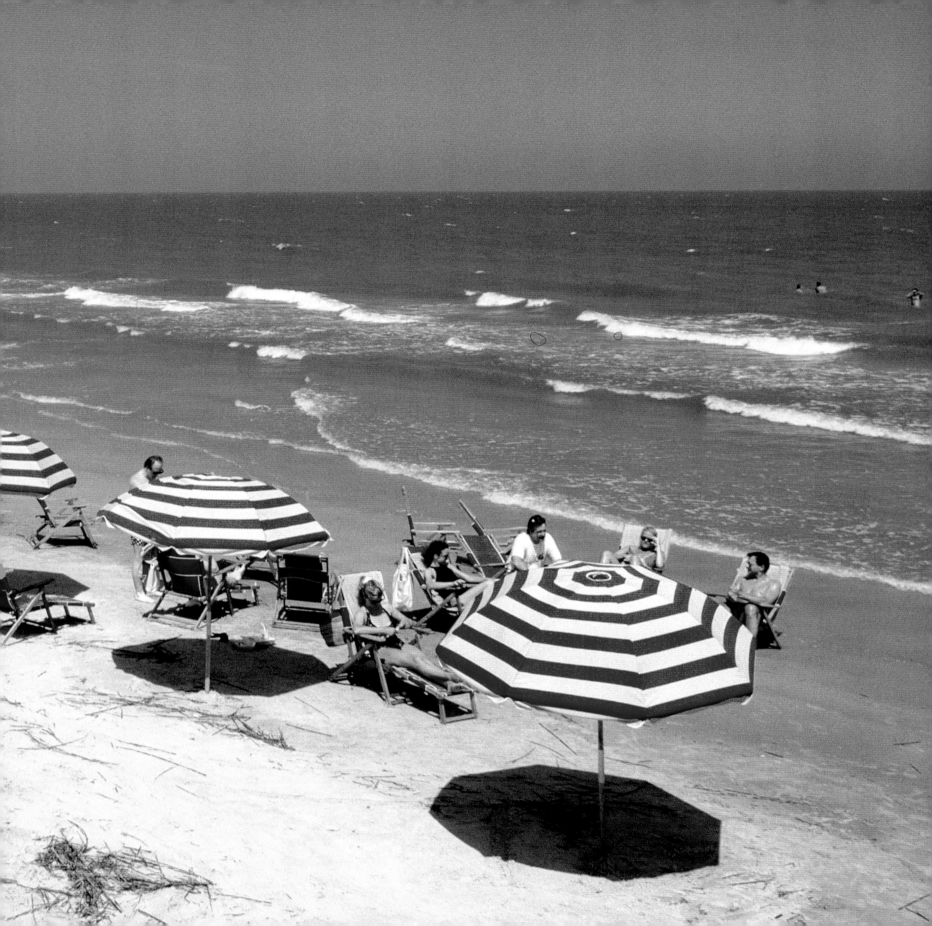

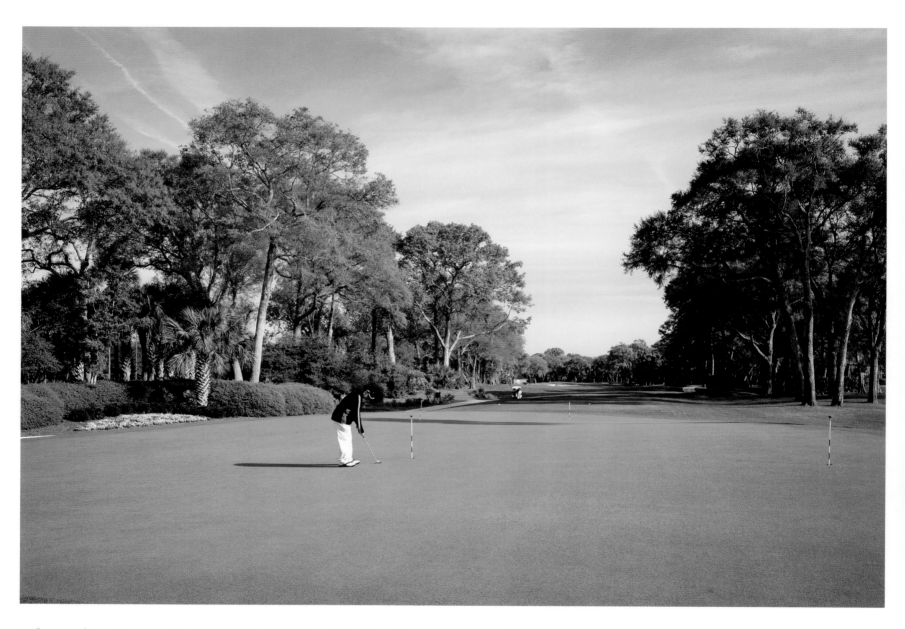

Often referred to as the Golf Island, Hilton Head is home to more than 20 championship courses. The game has been a Lowcountry tradition since Scottish immigrants organized America's first golf club, the Crail Golfing Society of South Carolina, in 1786.

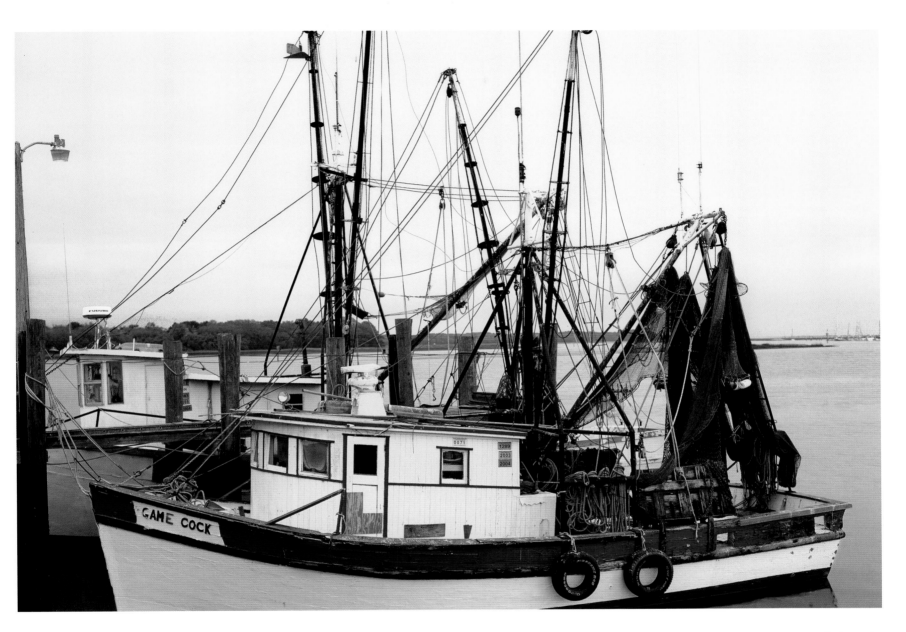

The warm ocean waters around Hilton Head Island are bountiful with snapper, grouper, kingfish, bluefish, swordfish, shark, and shrimp.

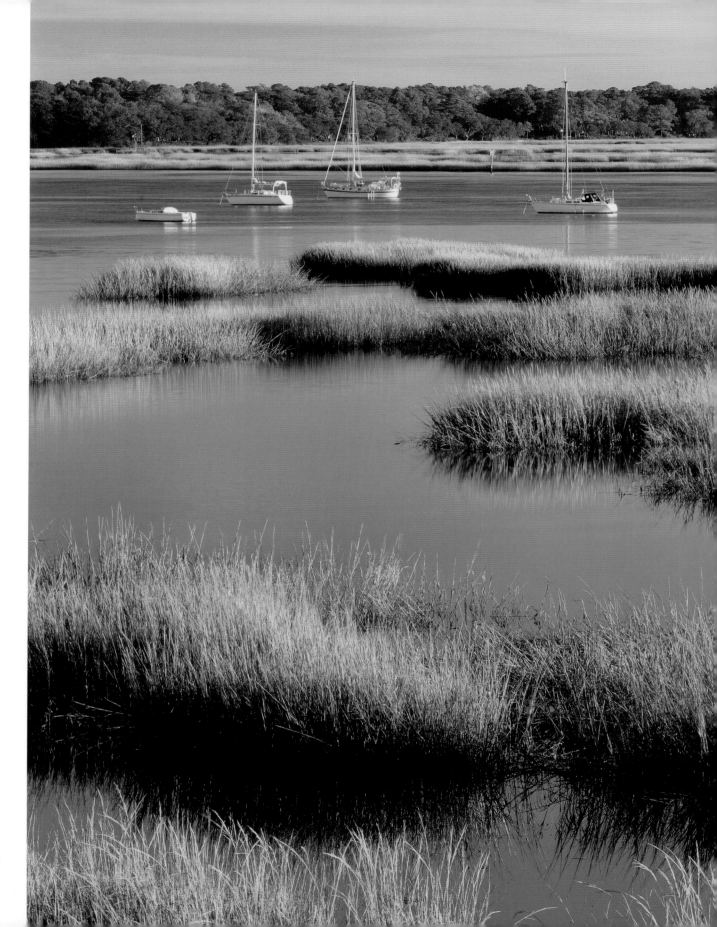

Beaufort lies next to vast salt marshes at the southern reaches of the Ashepoo, Combahee and South Edisto (ACE) Basin. The basin is one of the largest pristine estuaries on the East Coast. Its diverse habitats include pine and hardwood forests, wetlands, tidal marshes, barrier islands and beaches. Boating, fishing, and bird-watching popular recreational activities in the area. Bird-watching is especially rewarding because of the estuary's location on the Atlantic Flyway migration route.

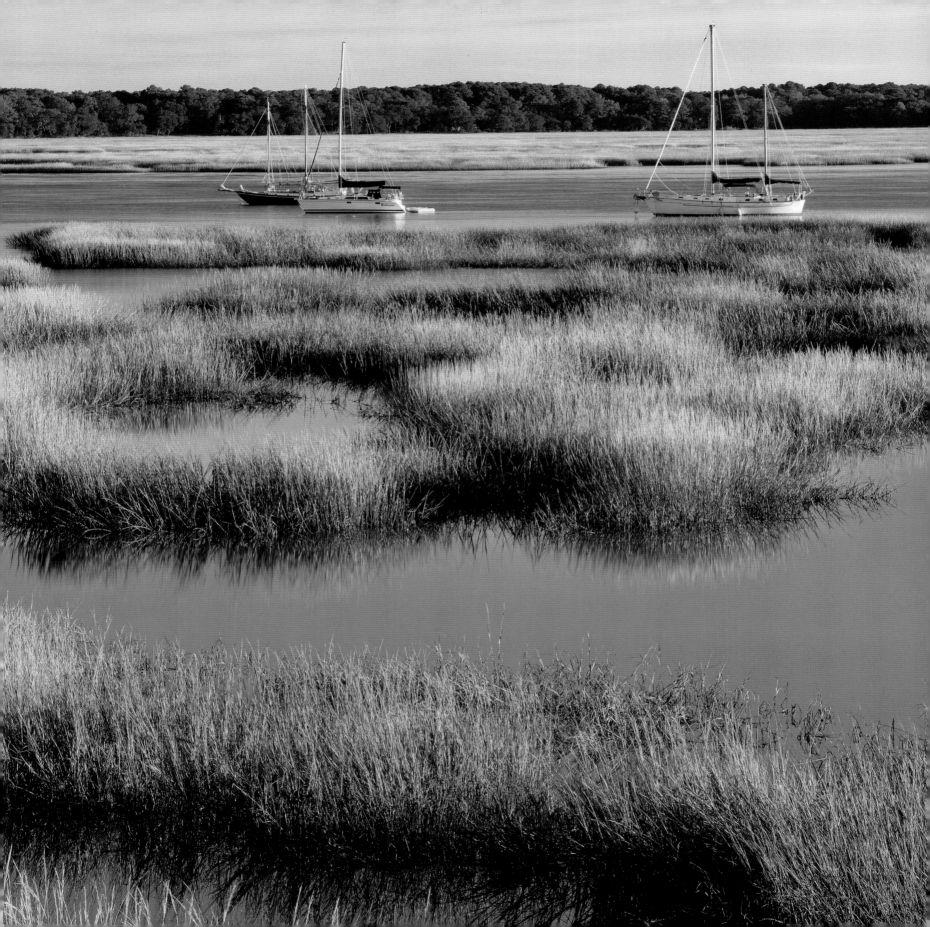

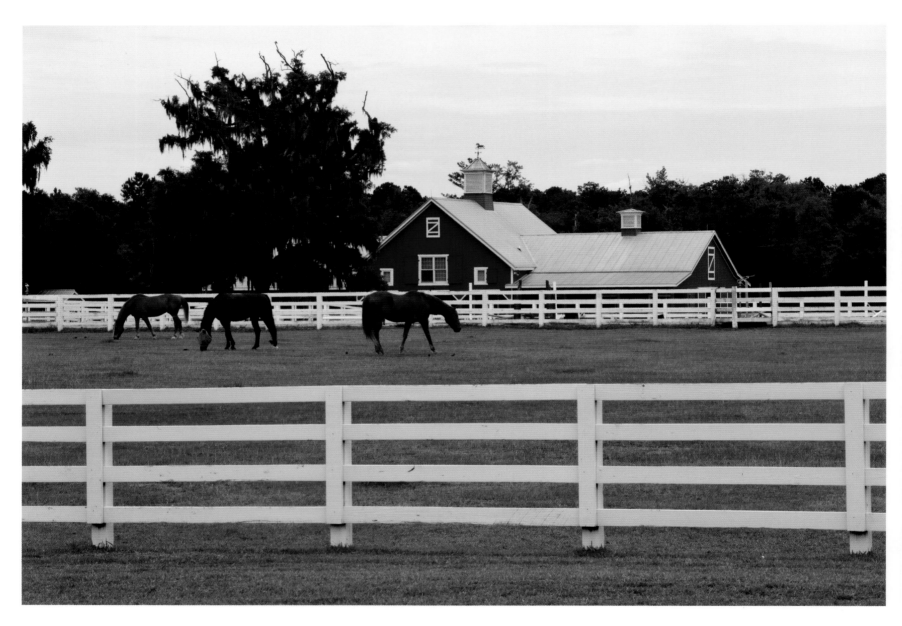

The lush rural areas in Jasper County provide a bountiful setting for diverse agricultural activities, including horse rearing for recreational riding, equestrian competition, and professional racing.

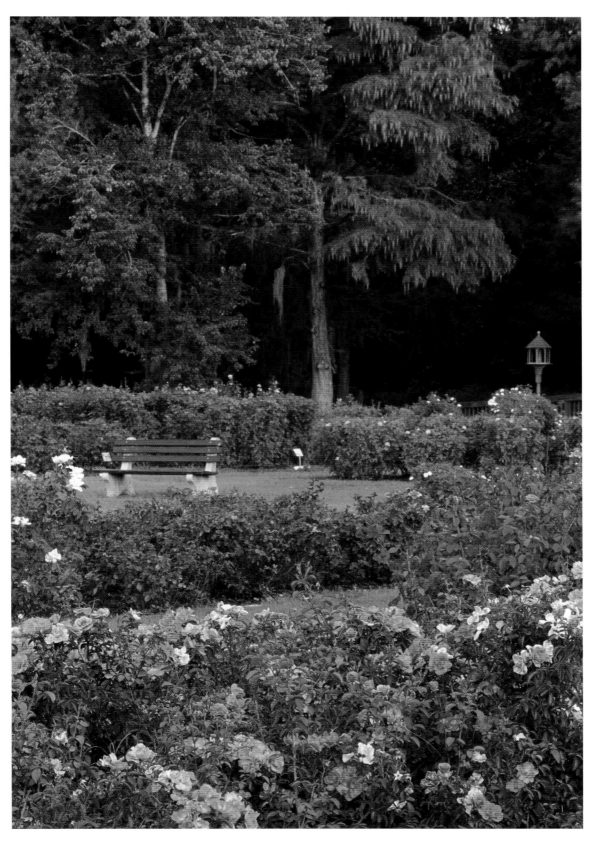

Orangeburg's Edisto Memorial Gardens commemorate a group of Confederate soldiers that temporarily halted the advance of the Union Army. The Gardens host the South Carolina Festival of Roses each year in April. At least 75 varieties of roses are represented in the 4,000 plants that are cultivated here.

OVERLEAF—
Located on the Congaree River, Congaree National Park protects the nation's largest remaining old-growth bottomland hardwoods. Within the 22,000 acres of parkland stands one of the world's tallest deciduous forests.

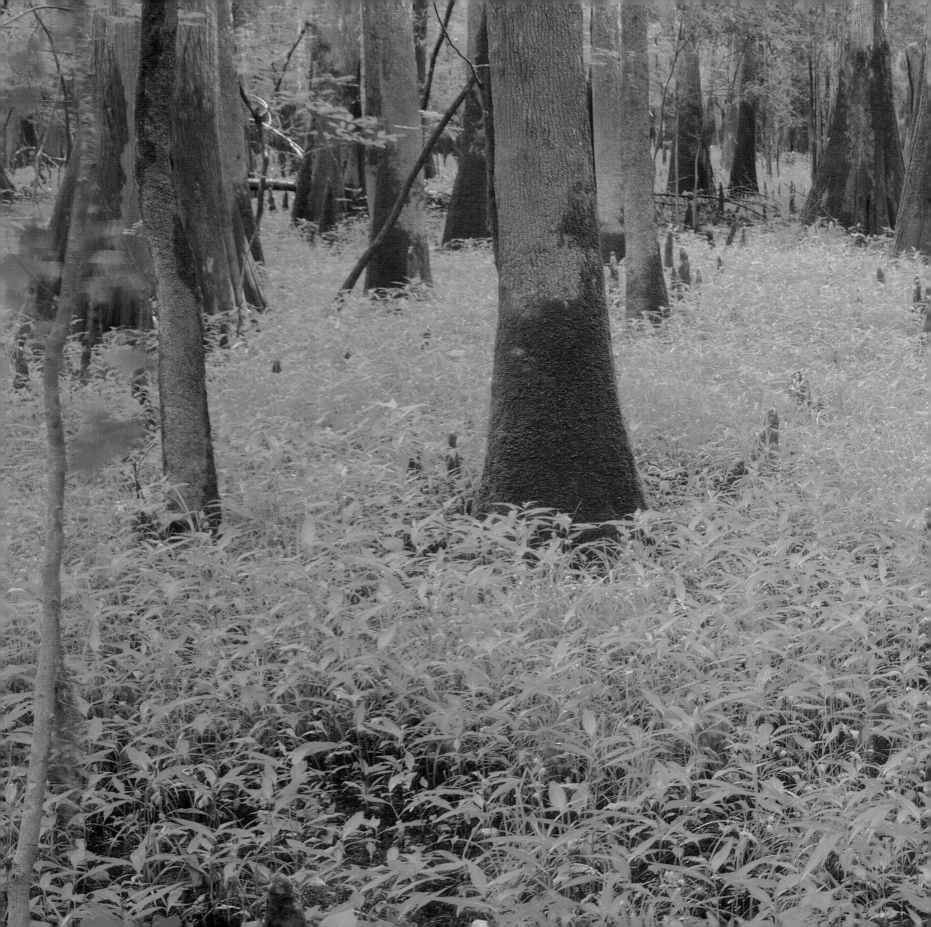

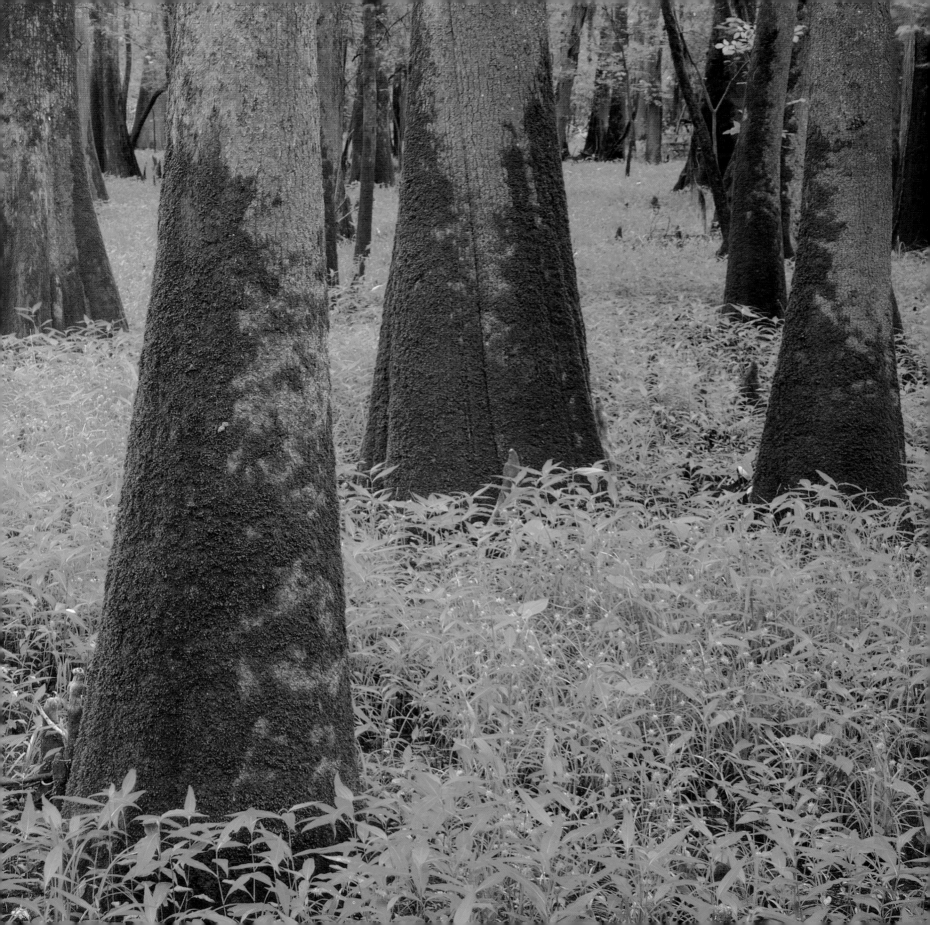

In 1790, the capital city moved from Charleston to Columbia, prompted by tensions between the aristocratic Low-country and the poorer Upcountry. The new Capitol was designed in 1855, but construction stopped during the Civil War when the Union army attacked the building. The structure wasn't completed until 1907.

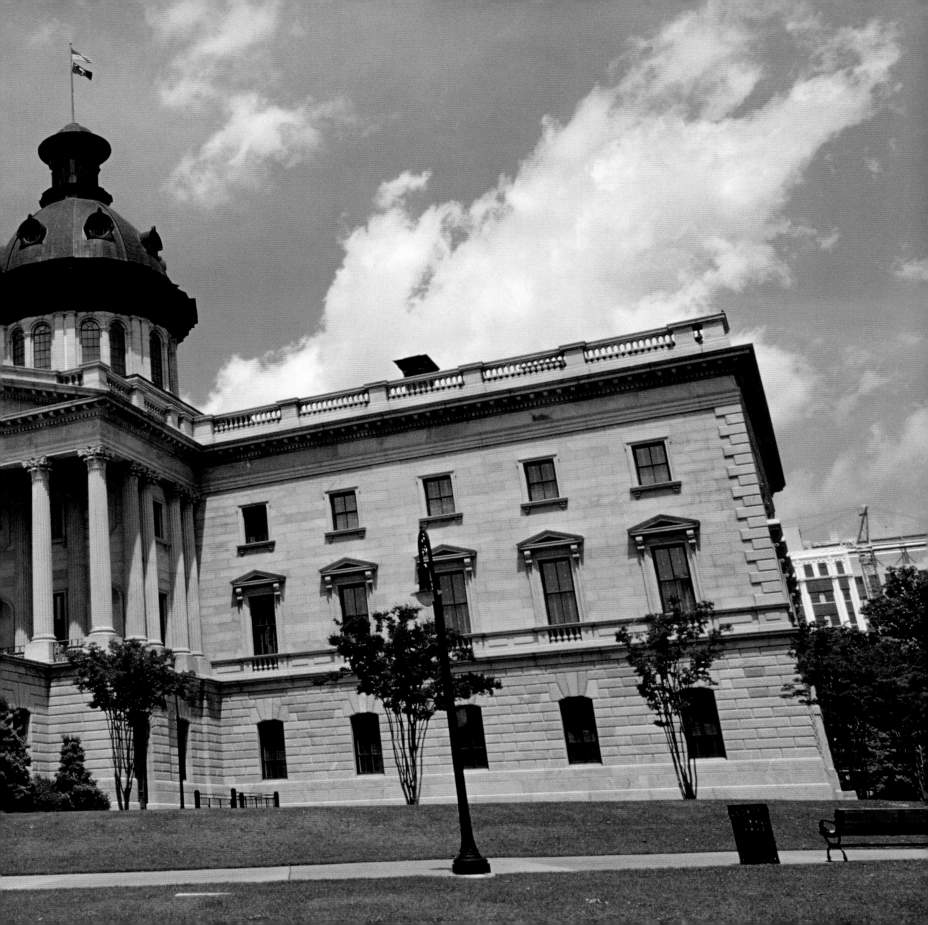

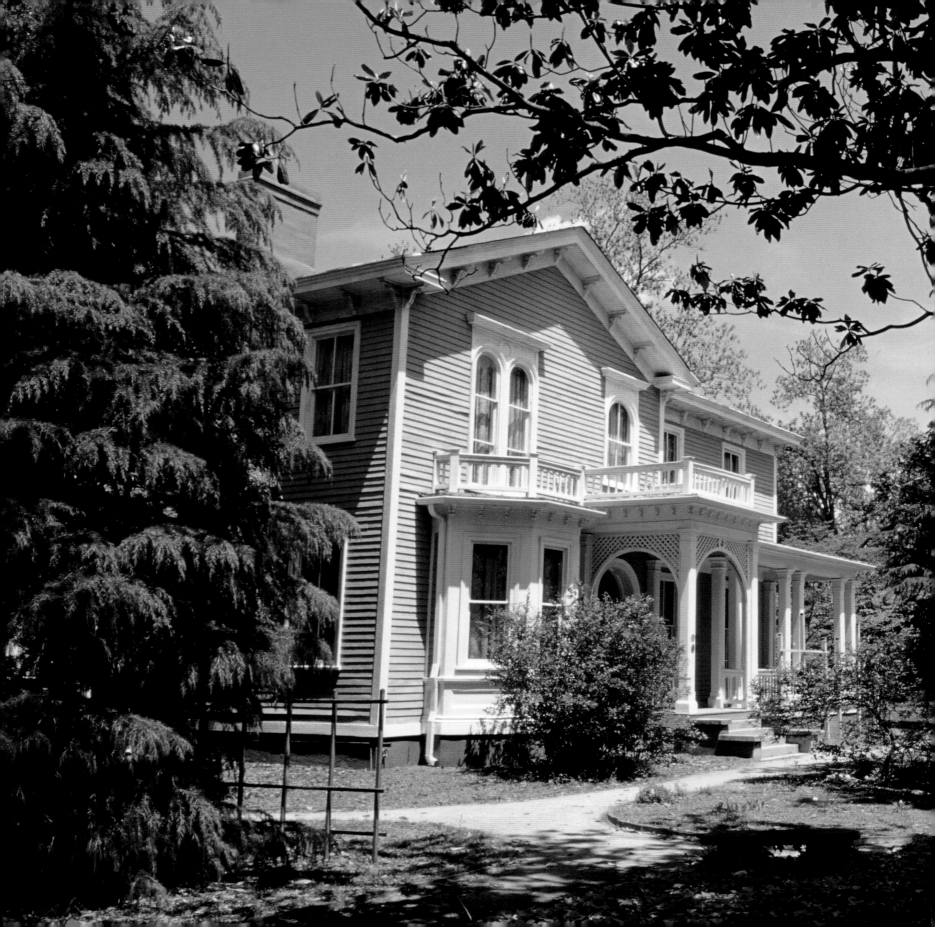

More than 100,000 people call Columbia their home. Once a colonial settlement, it's now a bustling modern center of business, art, and culture.

President Woodrow Wilson spent part of his teenage years in Columbia. Although his family lived in the city for only four years, his former home is preserved as a museum.

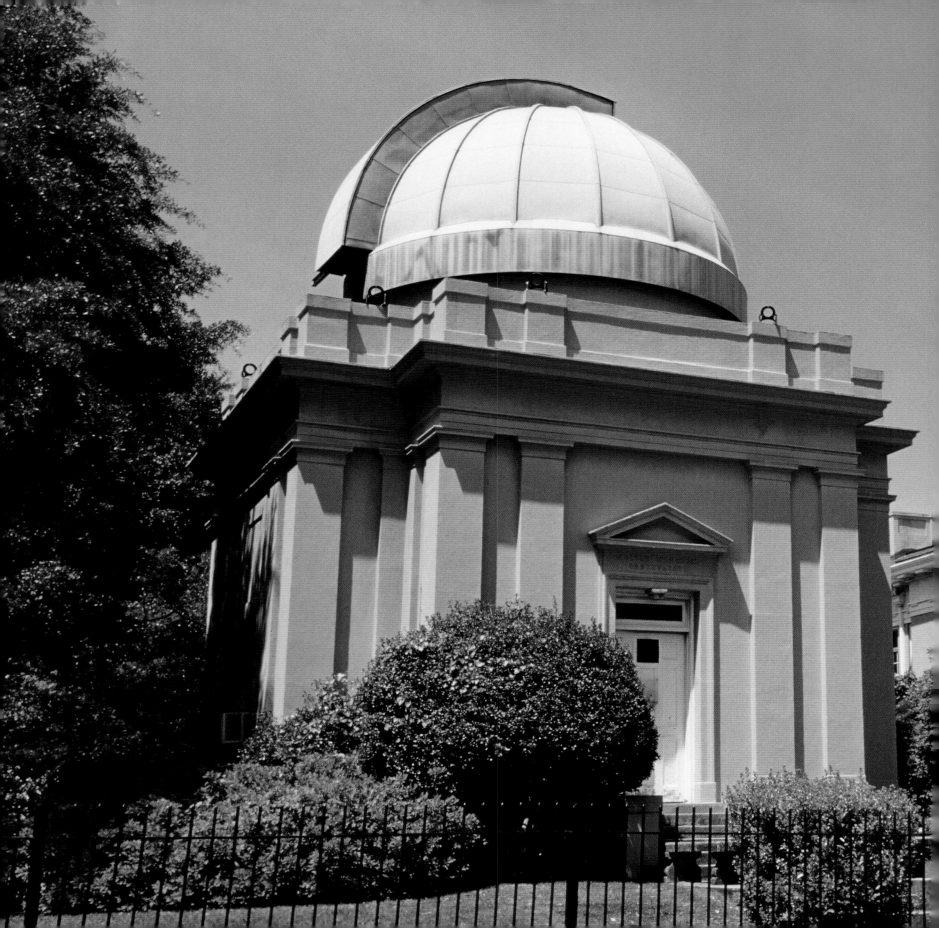

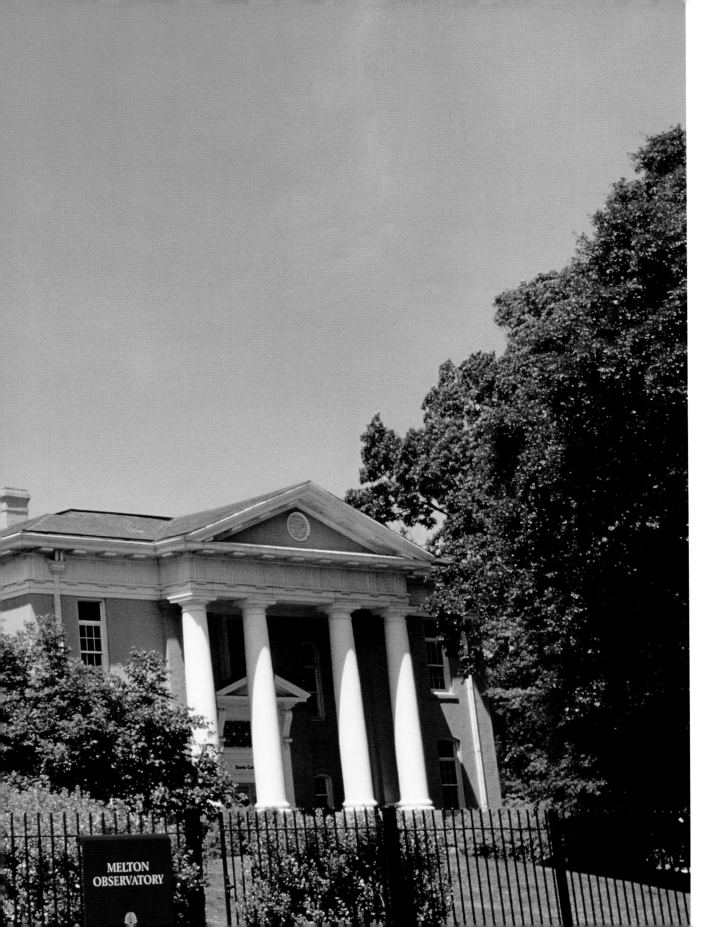

MELTON
OBSERVATORY

The University of South Carolina in Columbia, offers some 324 undergraduate and graduate degree programs on eight campuses. The university, founded in 1801, now awards over 8,000 degrees each year and has a student body of about 44,000.

61

Lake Murray is a large man-made lake west of Columbia, with more than 500 miles of shoreline. In order to create the lake, more than 1,000 tracts of land were acquired and 5,000 homes relocated.

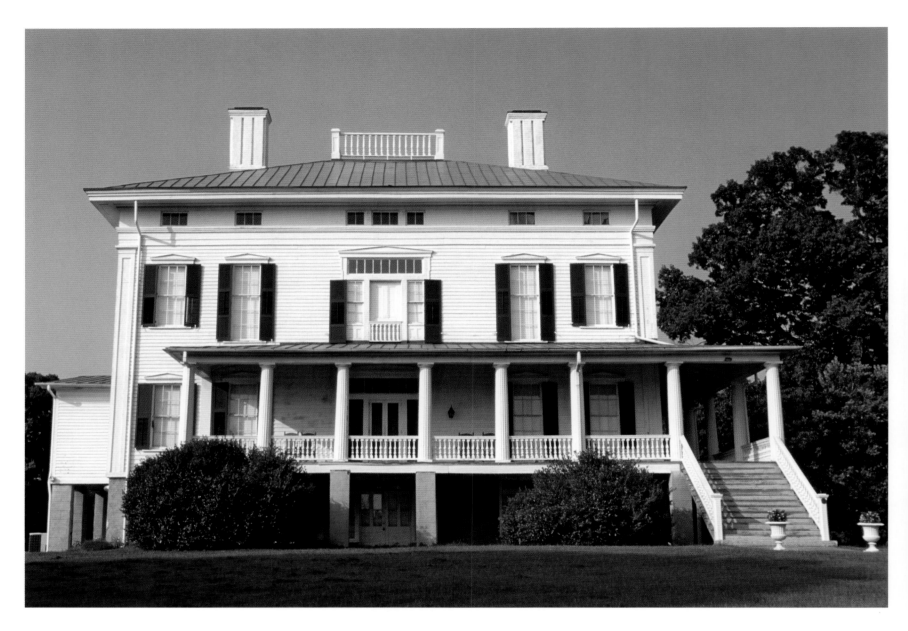

This mansion, on the Redcliffe Plantation State Historic Site, was once home to James Henry Hammond who was a politician best known as an outspoken defender of slavery and states' rights. In 1858, he coined the phrase "Cotton is King" in a speech to the Senate.

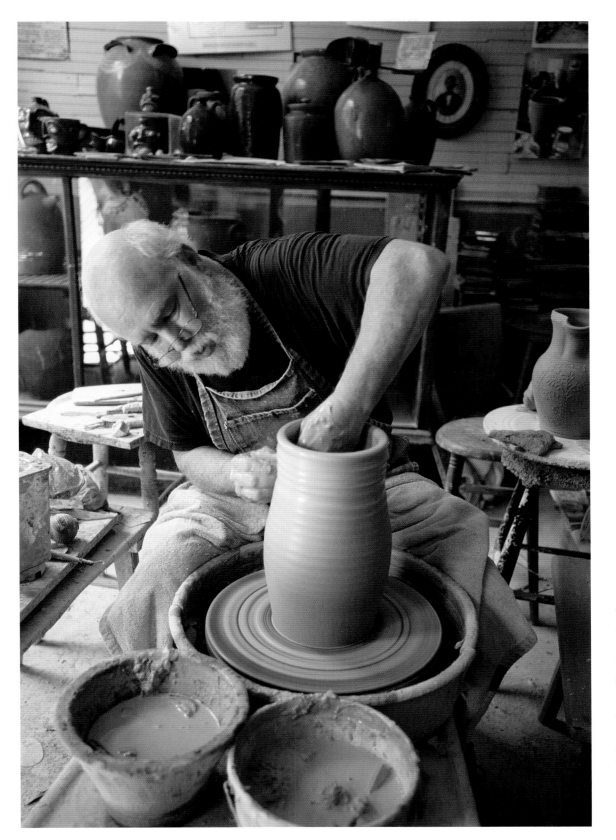

The Old Edgefield Pottery, in the town of Edgefield, tells the story of traditional 19th-century pottery. Today, resident potters give demonstrations of the craft.

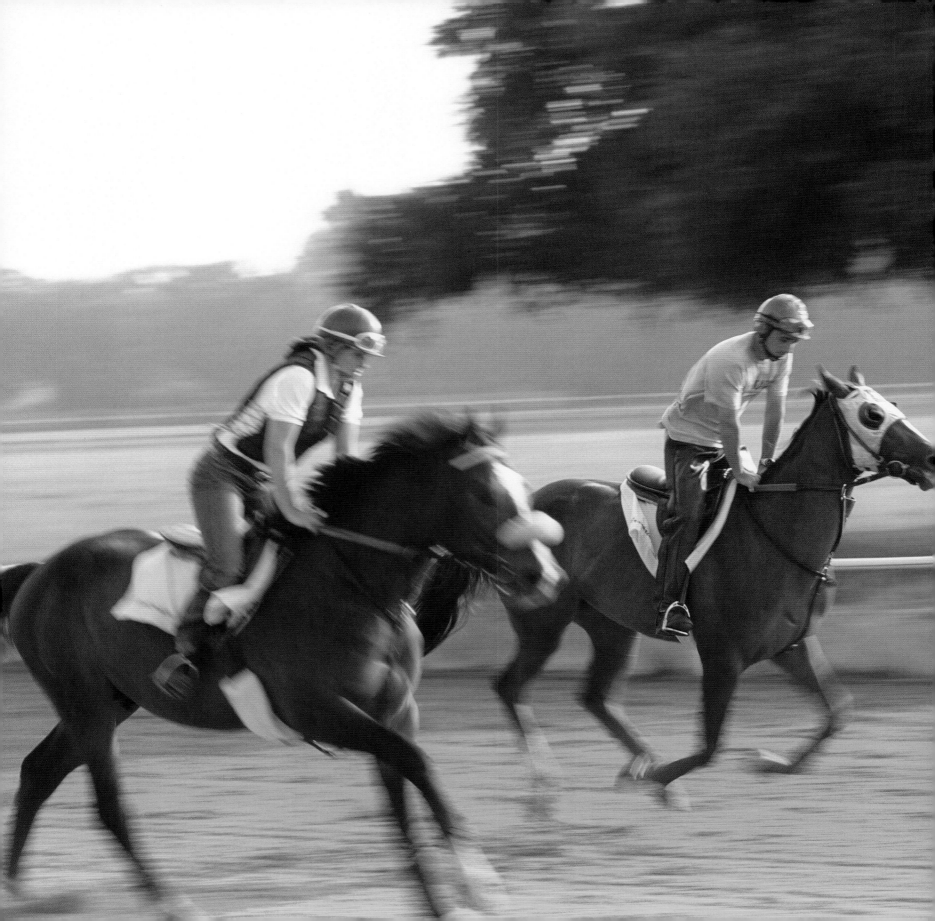

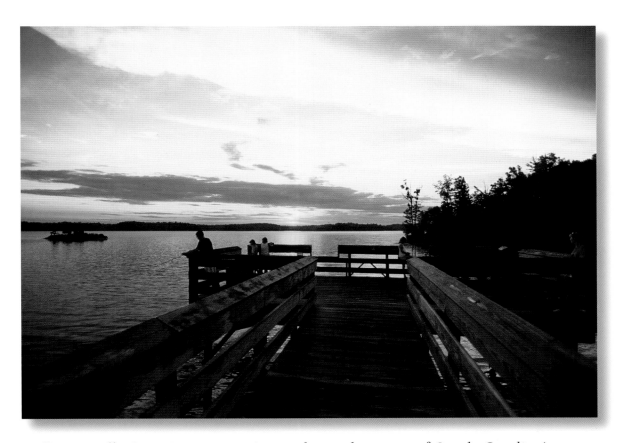

Calhoun Falls State Recreation Area is located on one of South Carolina's most popular fishing lakes, Lake Russell. The area's picturesque natural surroundings are ideal for camping, hiking, tennis, and swimming.

The town of Aiken has a long history of equestrian sports. Today, it hosts the Aiken Triple Crown—a three-event competition combining track racing, steeplechase, and polo.

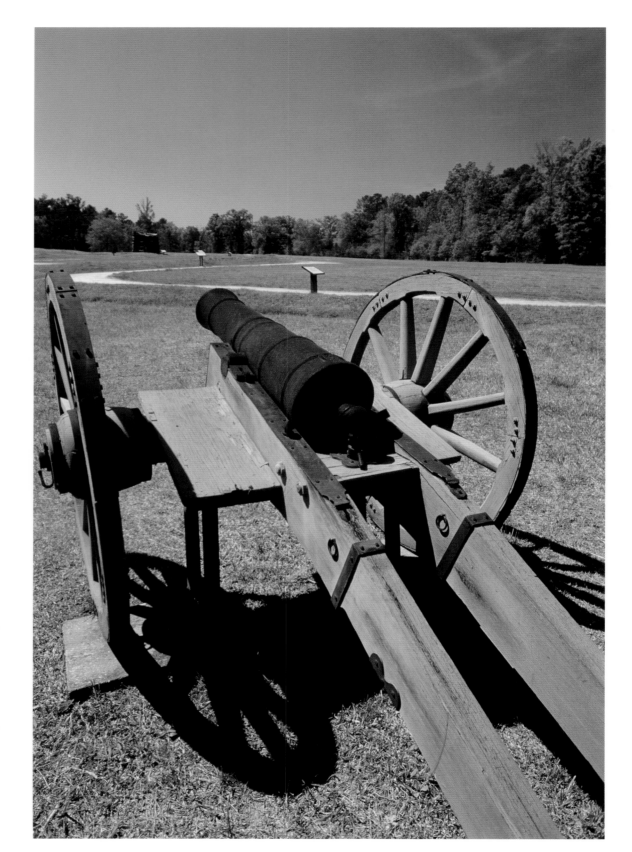

The Ninety Six
National Historic
Site was the stage
for many significant
battles during the
American Revolution.
It was here that 550
Loyalists defended
the site against 1,000
Patriot troops in the
longest, yet ultimately
unsuccessful, siege of
the Revolutionary War.

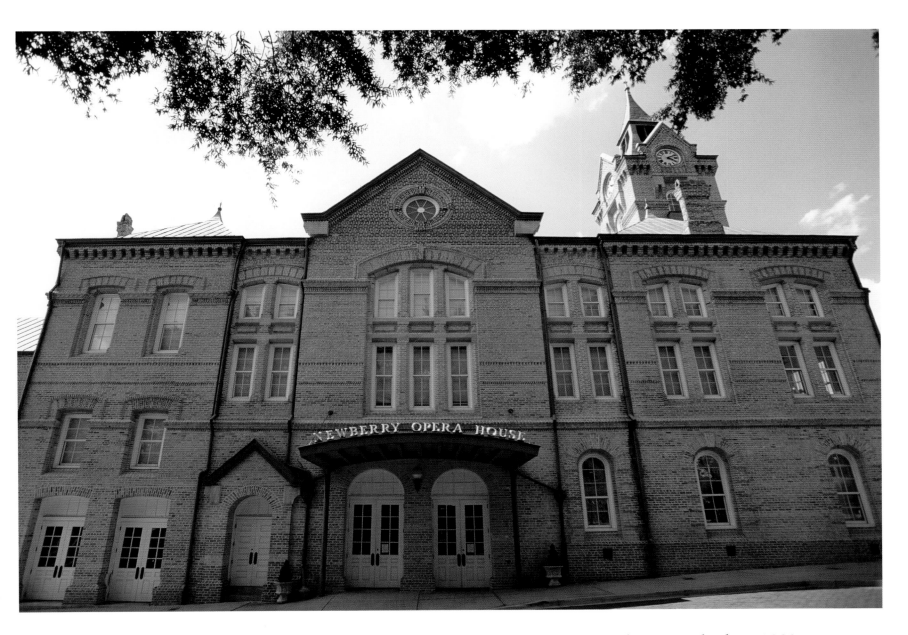

The Opera House in Newberry was built in 1881, at a cost of $30,000. It still hosts a variety of concerts, including jazz, gospel, and Broadway performances.

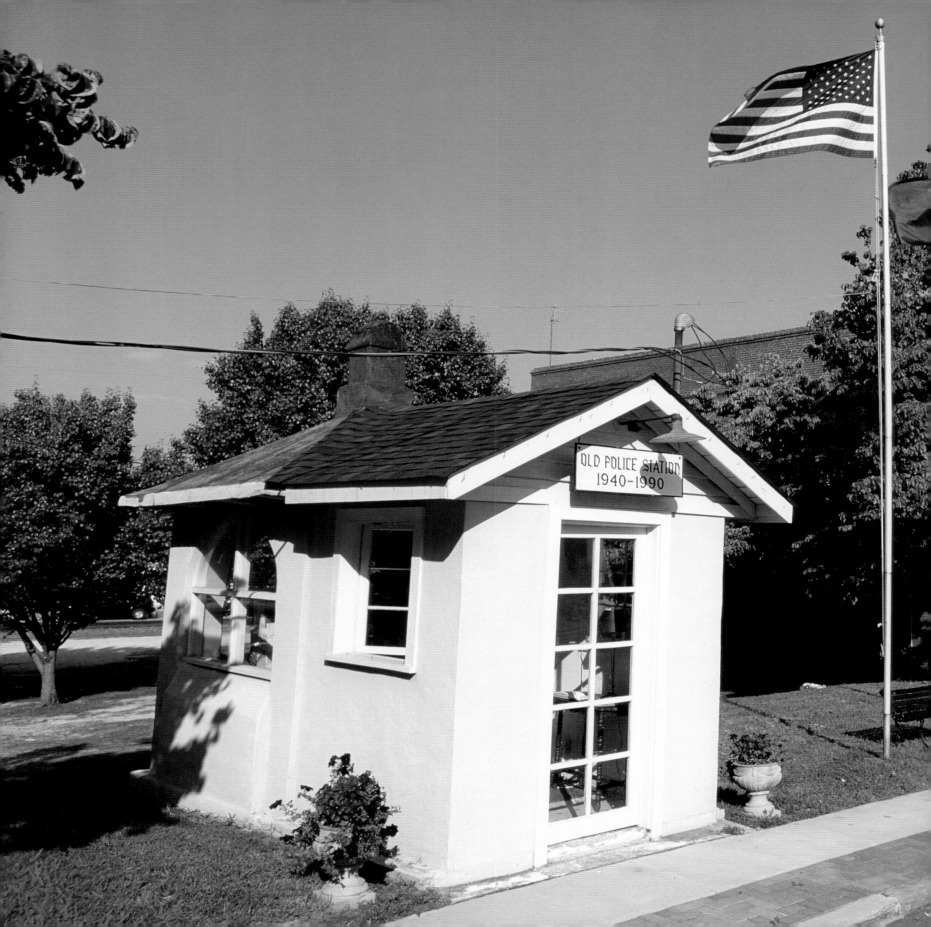

Camden is an equine enthusiast's paradise. Horse shows and polo games take place year-round, and visitors can often watch championship racehorses train. The town is famous for the Carolina and Colonial Cup steeplechase races.

The town of Ridgeway is home to the world's smallest police station. This tiny one-room station was used until 1990 and was an official stopping point for the Olympic torch in 2006.

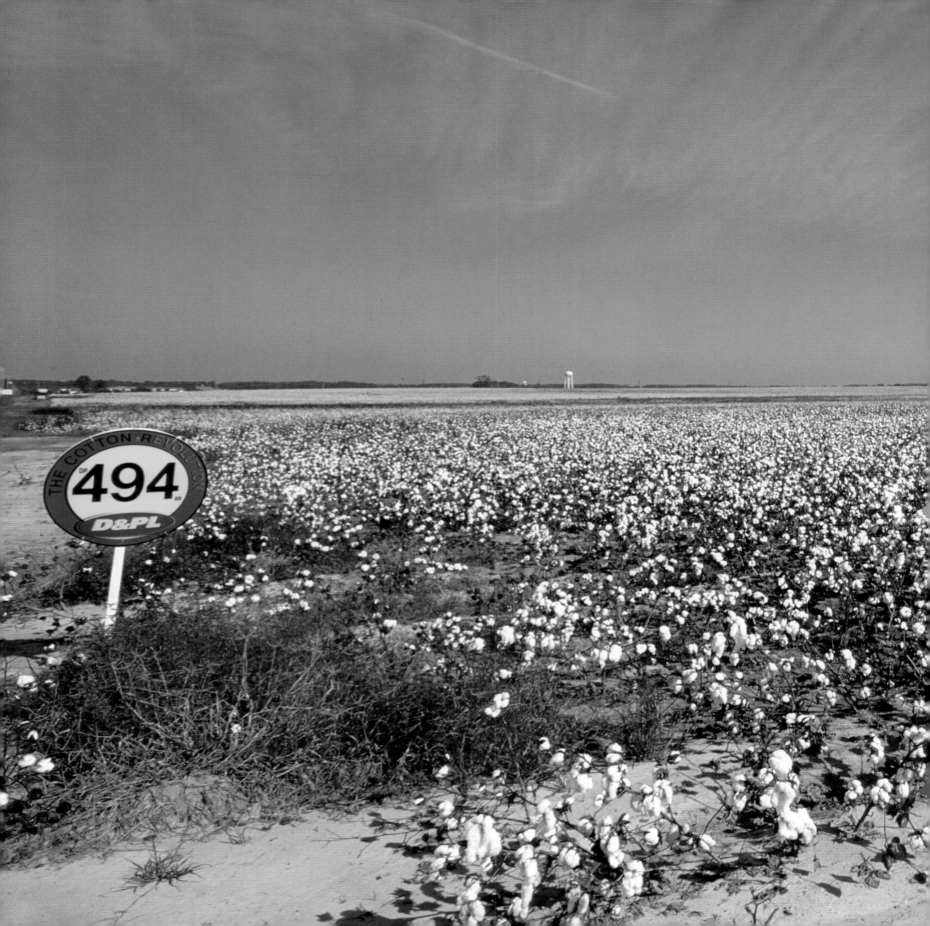

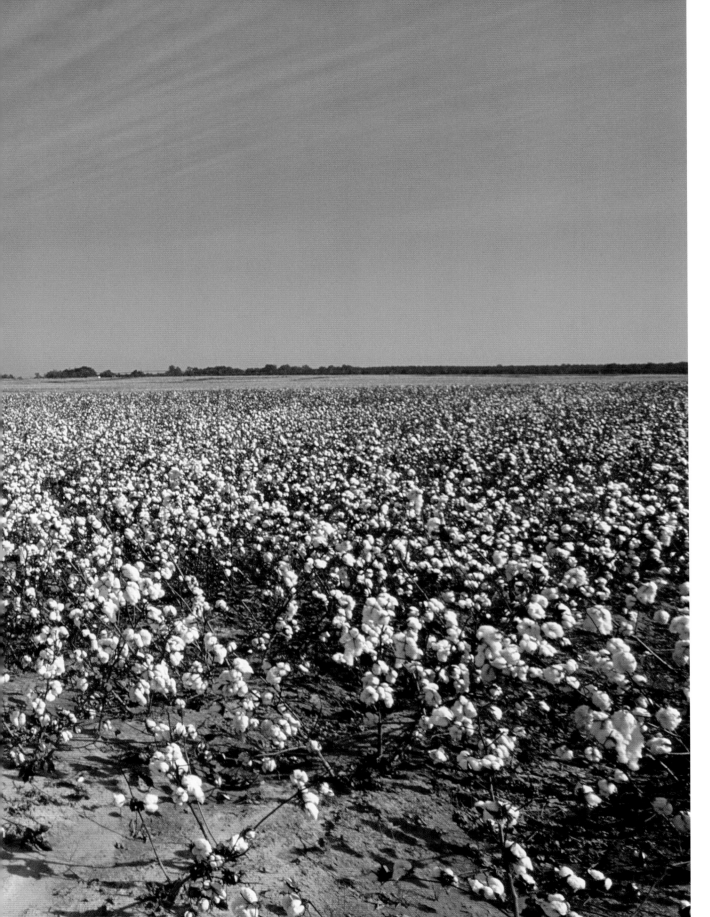

Cotton has played an important part in the state's history. For much of the 19th and 20th centuries, cotton, and other textiles, were the state's primary industries. Today, cotton is South Carolina's second-largest crop. The Cotton Trail—a scenic byway from Clio to Bishopville—outlines the crop's historical significance through museums, homesteads, and cotton fields.

73

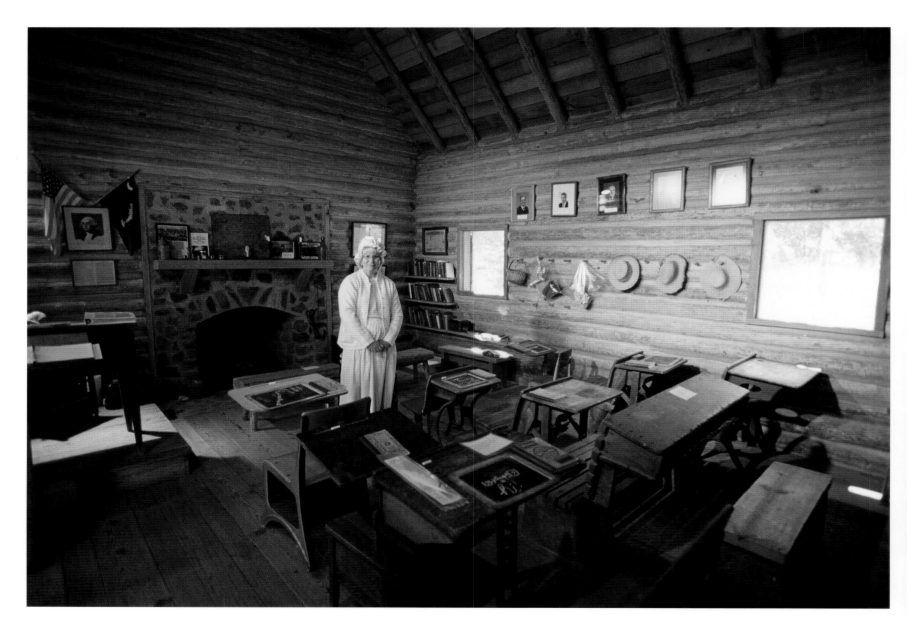

Honoring the nation's seventh president, Andrew Jackson State Park includes a museum that tells of Jackson's boyhood experiences during the Revolutionary War and highlights his life from his birth in 1767 until he left South Carolina in 1784.

One of the stops along the Cotton Trail, the town of Cheraw is also the birthplace of jazz great John Birks "Dizzy" Gillespie.

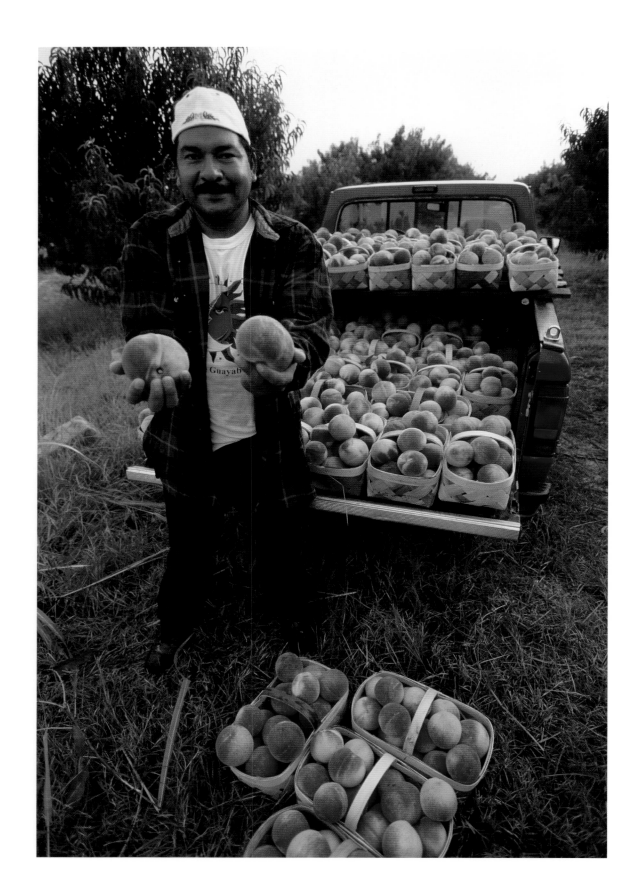

Nicknamed the "Tastier Peach State," South Carolina produces more than 200 million pounds of peaches a year. The state ranks second in the nation for fresh peach production and domestic shipments.

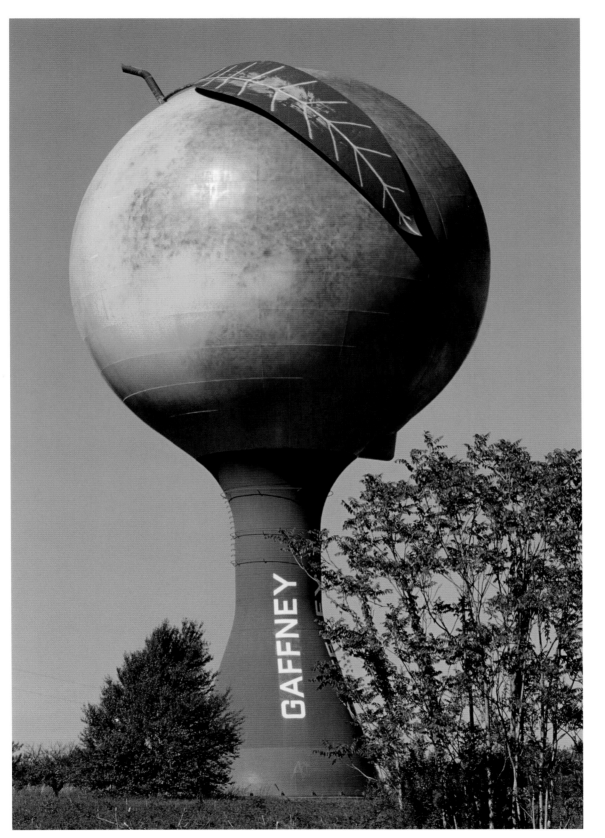

Home to the South Carolina Peach Festival, the town of Gaffney erected this one-million-gallon peach-shaped water tower in 1981. The two-week festival hosts peach recipe competitions, musical performances, and craft shows.

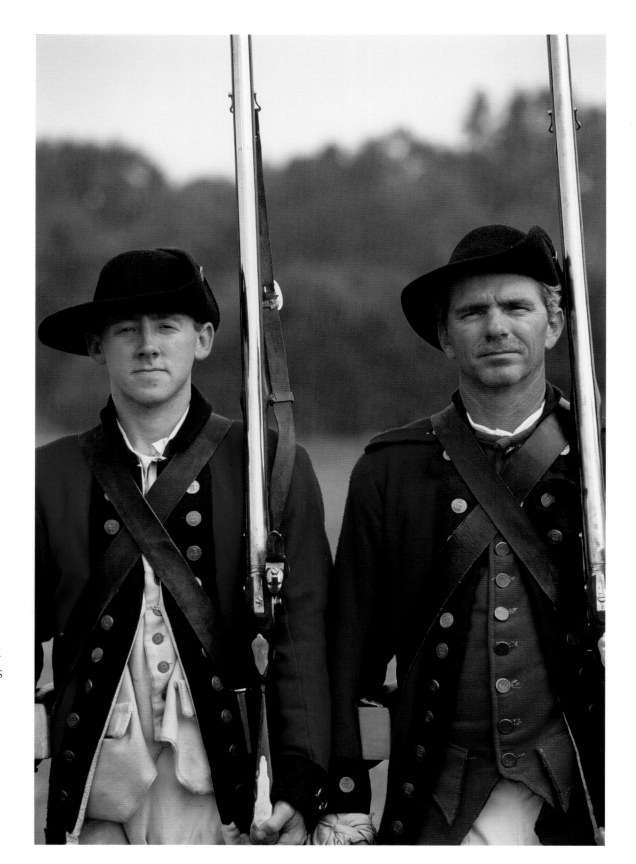

More than 200 Revolutionary War battles were fought in South Carolina. Kings Mountain National Military Park commemorates a pivotal victory by Patriots over Loyalists.

Visitors experience the lifestyle of early pioneers at the Living History Farm in Kings Mountain State Park. The park encompasses 6,883 acres of picturesque natural settings and offers a variety of outdoor activities.

The Cowpens
National Battlefield
is the site of one
of the most deci-
sive battles in the
American Revolution's
Southern Campaign.
On January 17, 1781,
Brigadier General
Daniel Morgan led
his army of tough
Continentals to defeat
Banastre Tarleton's
British force in a
battle that lasted
less than an hour.

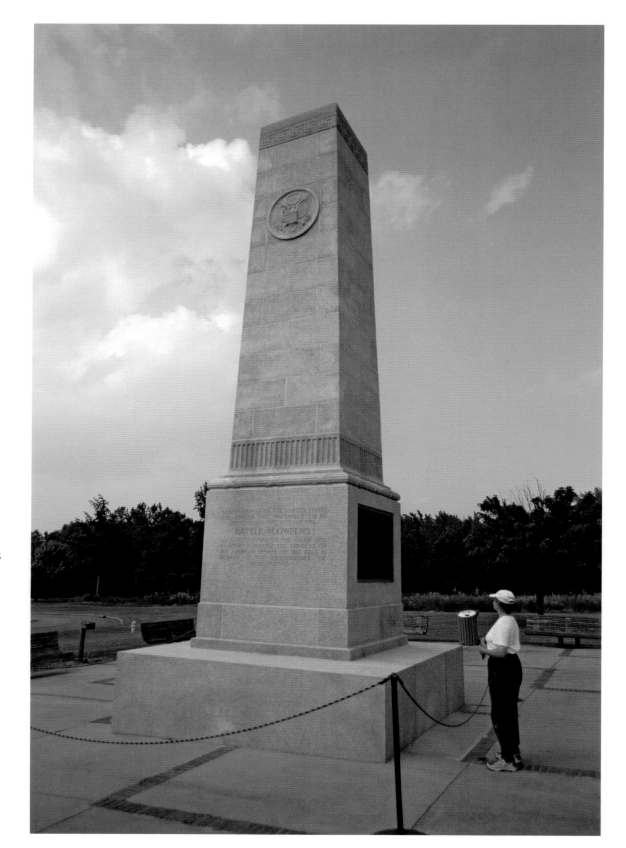

The Walnut Grove Plantation, home of Charles and Mary Moore, was built in 1765. Their eldest daughter, Kate Moore-Barry, was a scout for General Morgan at the Battle of Cowpens.

The US Army Corps of Engineers built Lake Hartwell in the early 1960s. Designed to control flooding of the Savannah River area, and for hydropower production, the lake has more than 960 miles of shoreline. Waterskiing, canoeing, and fishing are some of the many aquatic activities Hartwell has to offer.

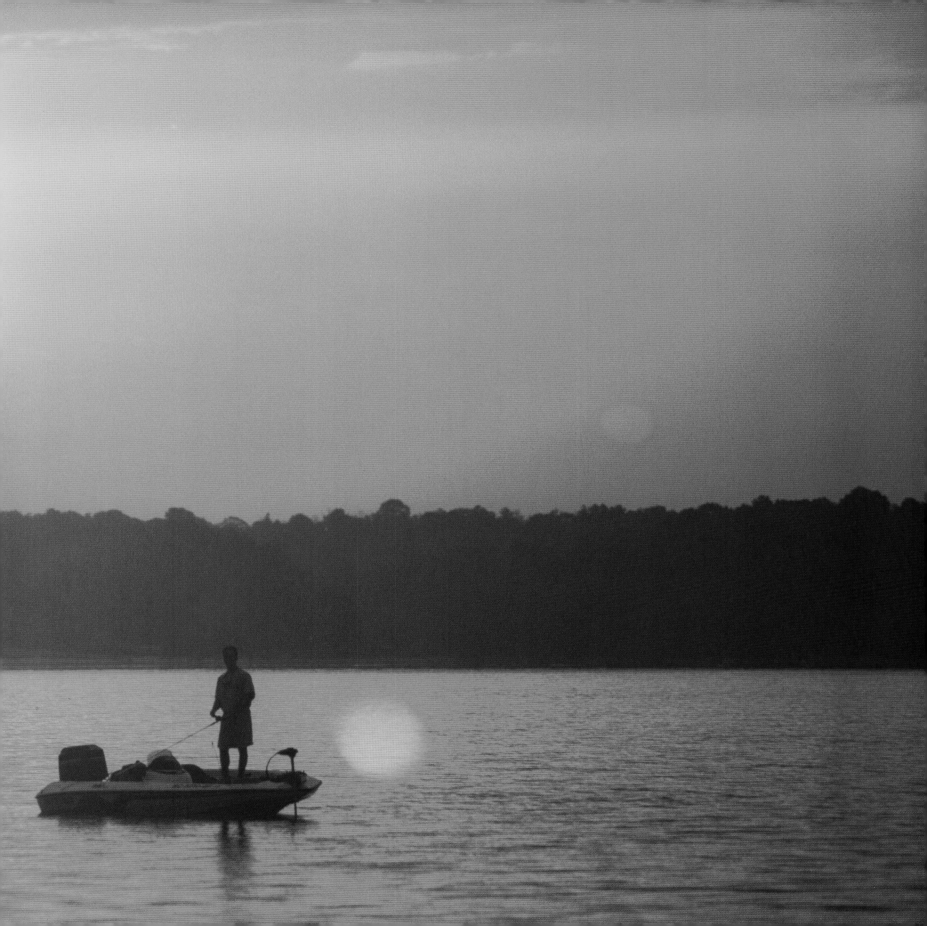

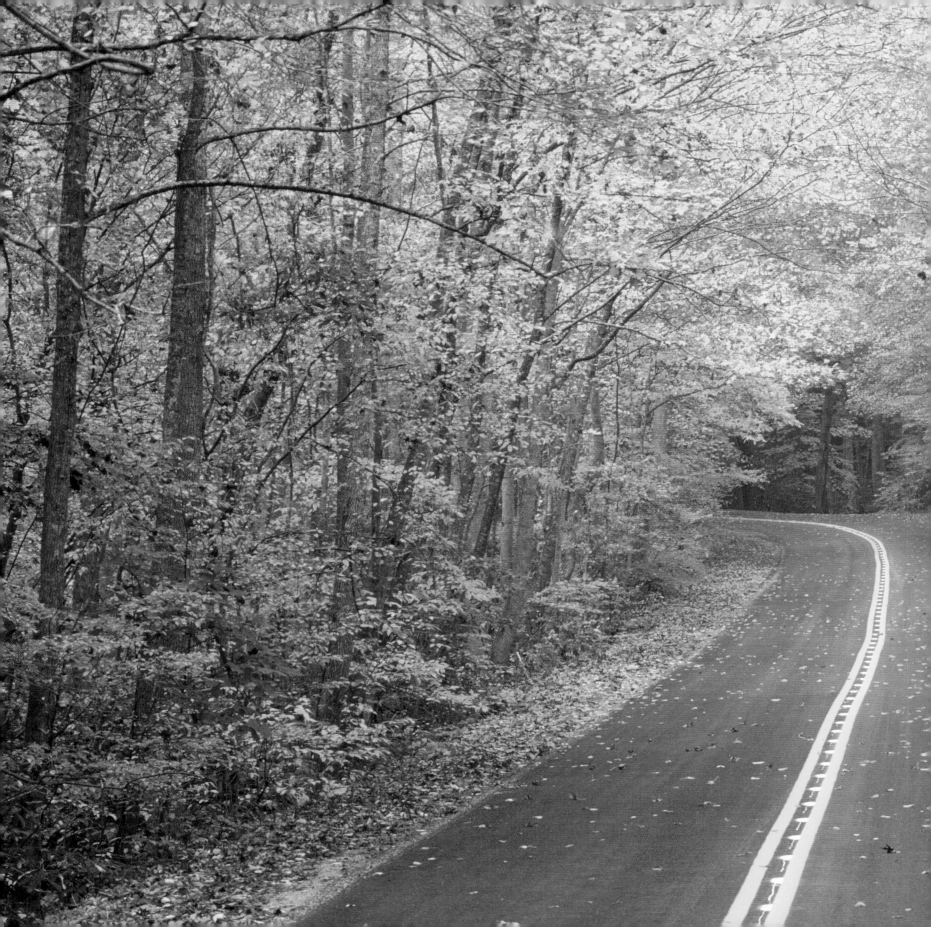

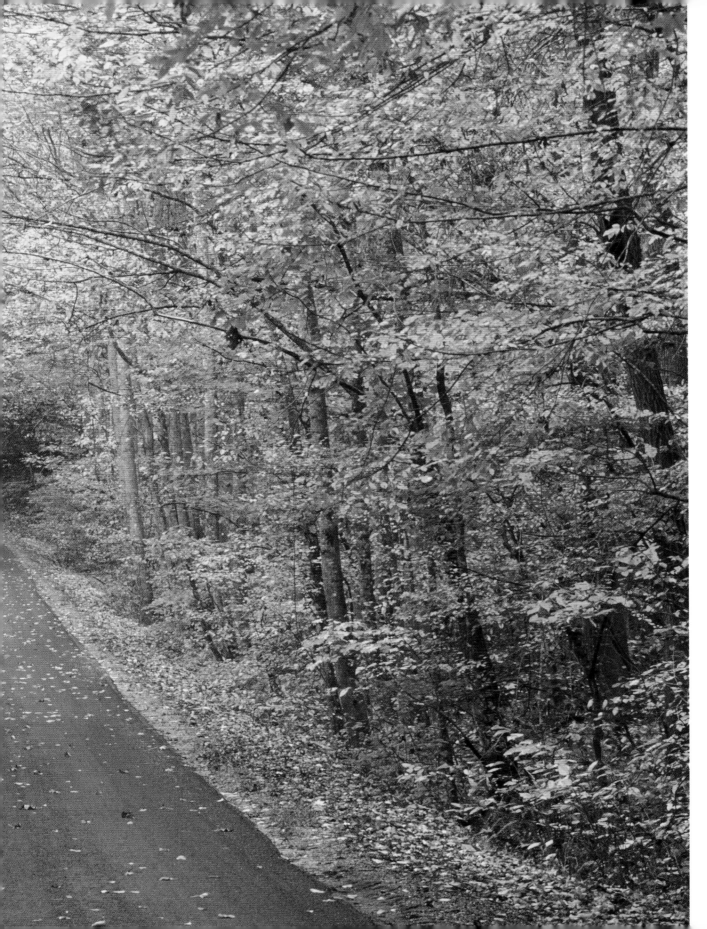

Winding through the northwest corner of the state, the Cherokee Foothills National Scenic Highway follows the southernmost peaks of the Blue Ridge Mountains. This 115-mile stretch of road passes by quaint villages, lush forests, and peach orchards.

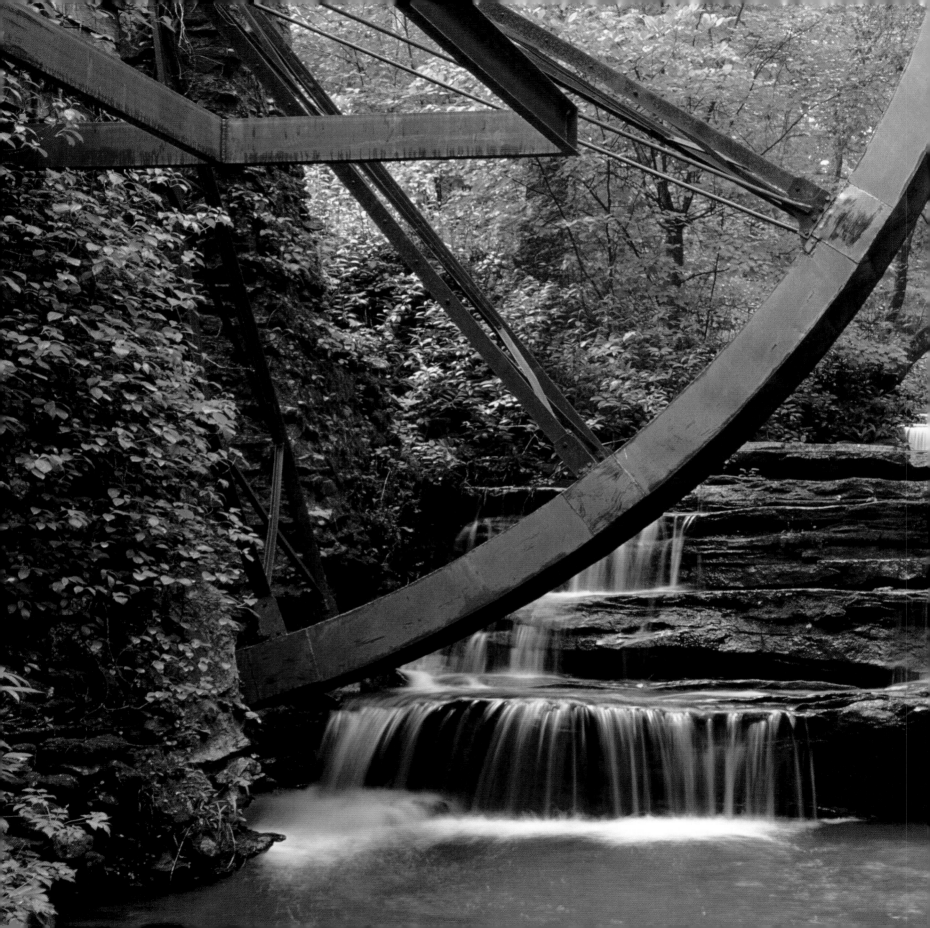

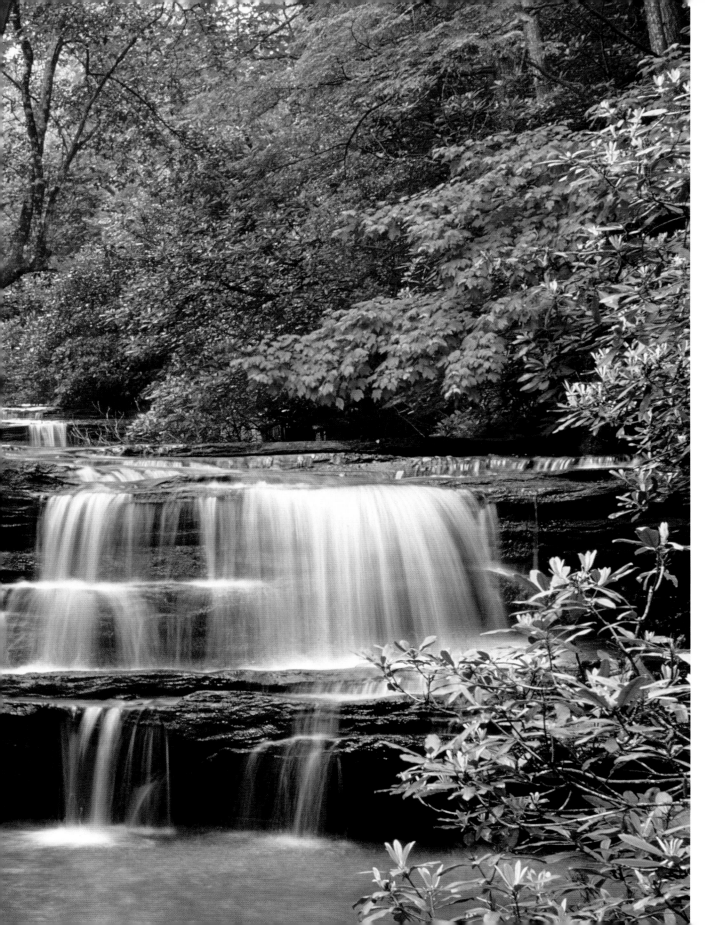

It's true that beauty comes in small packages. South Carolina only encompasses 31,113 square miles of land and is the nation's 40th-largest state.

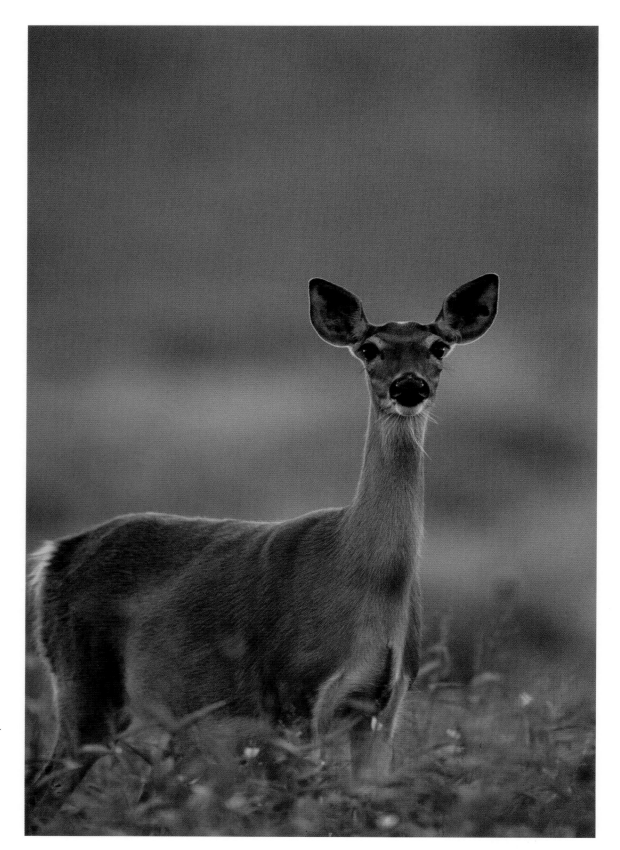

South Carolina's state animal, the whitetail deer, can be spotted in swamps, forests, and fields. These shy, majestic creatures can grow to weigh 350 pounds.

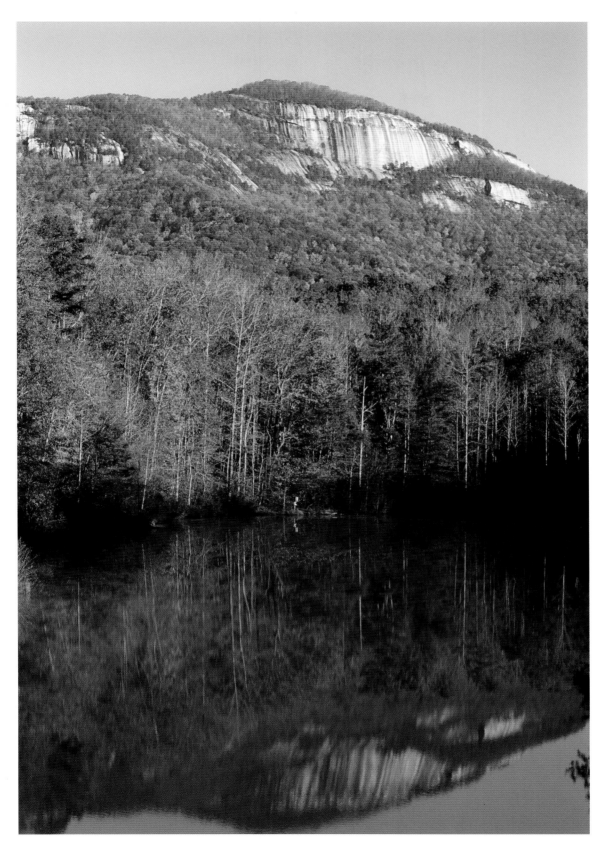

This breathtaking view of Table Rock Mountain, near the border of North Carolina, looks much the same today as it did to the Cherokee Indians who inhabited the area hundreds of years ago.

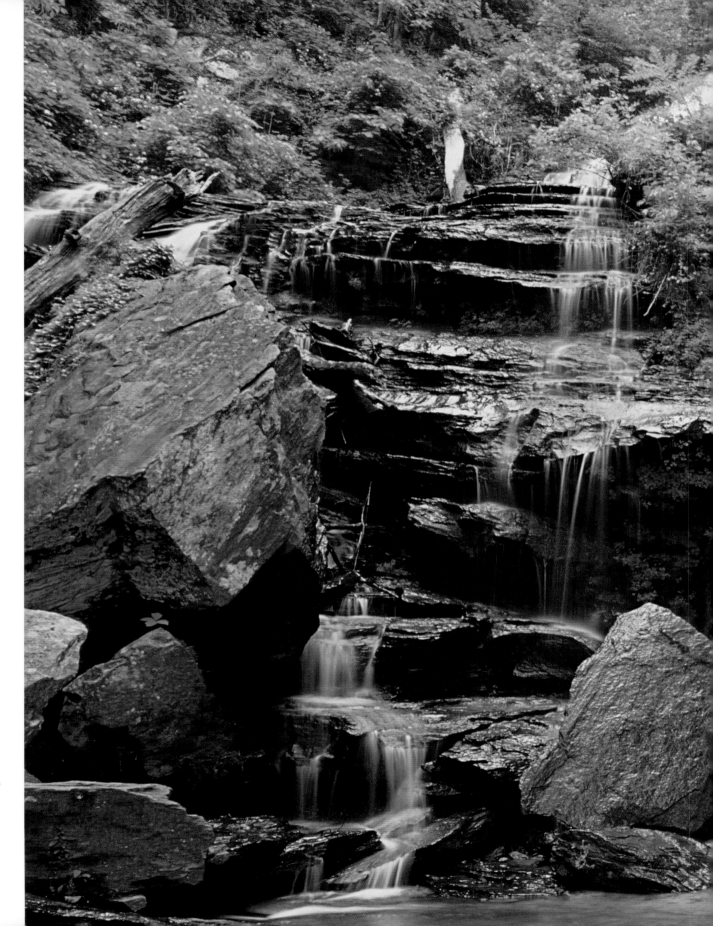

A beautiful 200-foot-high cascade, Issaqueena Falls is named for a Native American maiden. Legend has it the maiden warned settlers in a nearby fort of an impending attack. She then escaped her pursuers by pretending to leap over the falls but really hiding behind them.

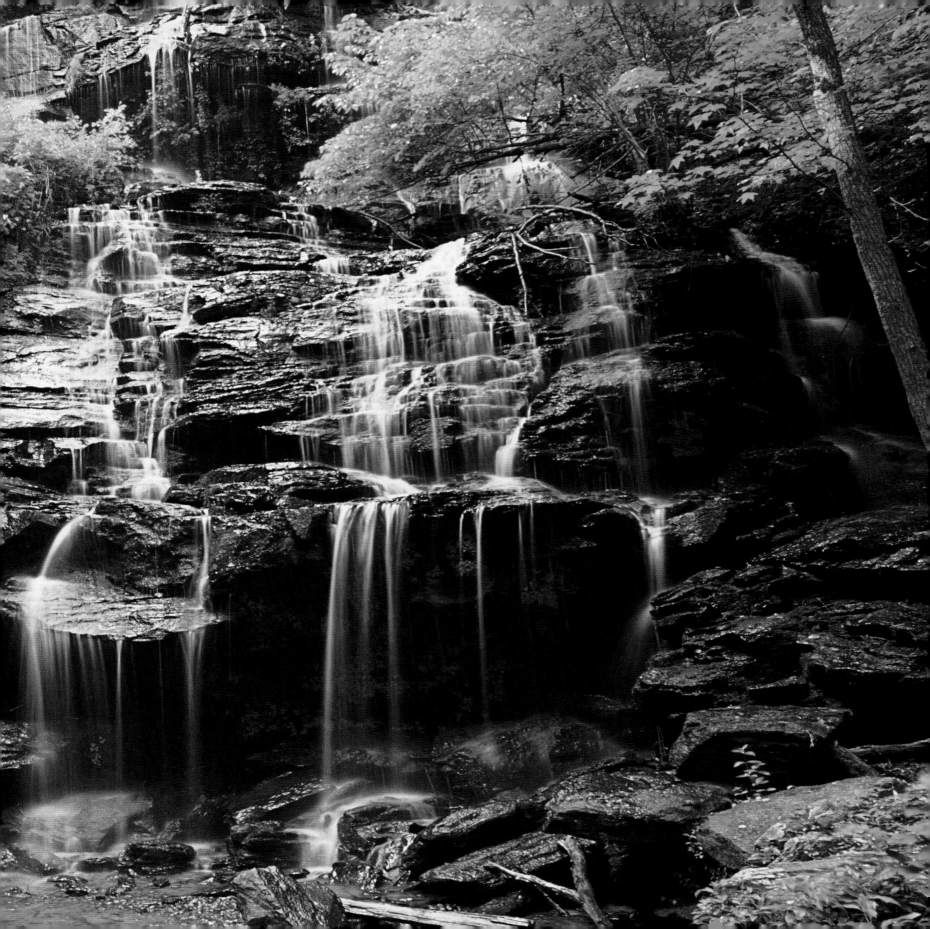

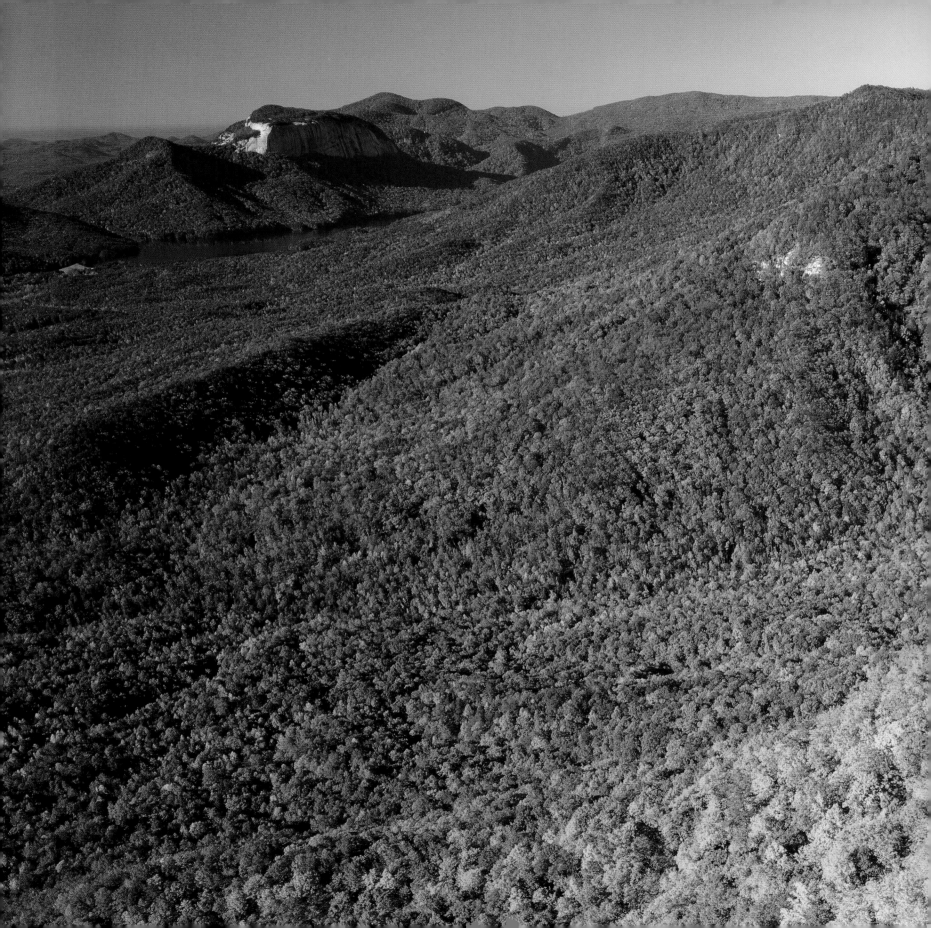

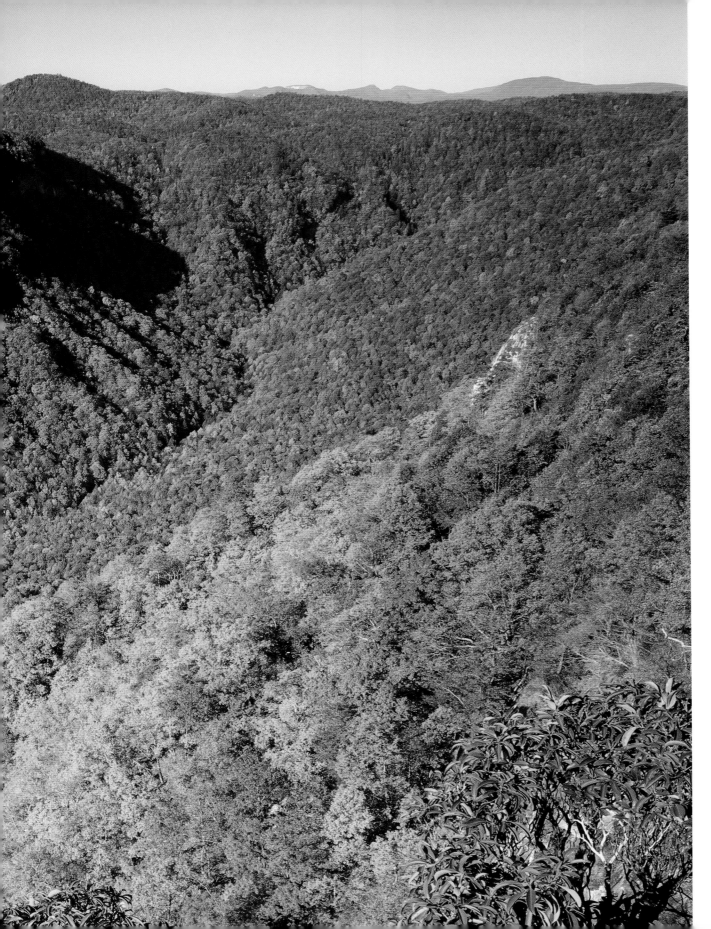

Caesars Head State Park has over 50 miles of hiking trails that wind through the awe-inspiring Blue Ridge Mountains—part of the vast Appalachian mountain range that extends approximately 1,500 miles from southeastern Canada into central Alabama.

OVERLEAF—
The Fred W. Symmes Wedding Chapel at the YMCA Camp Greenville, is aptly nicknamed "Pretty Place" because of this spectacular view over-looking the Southern Appalachian foothills.

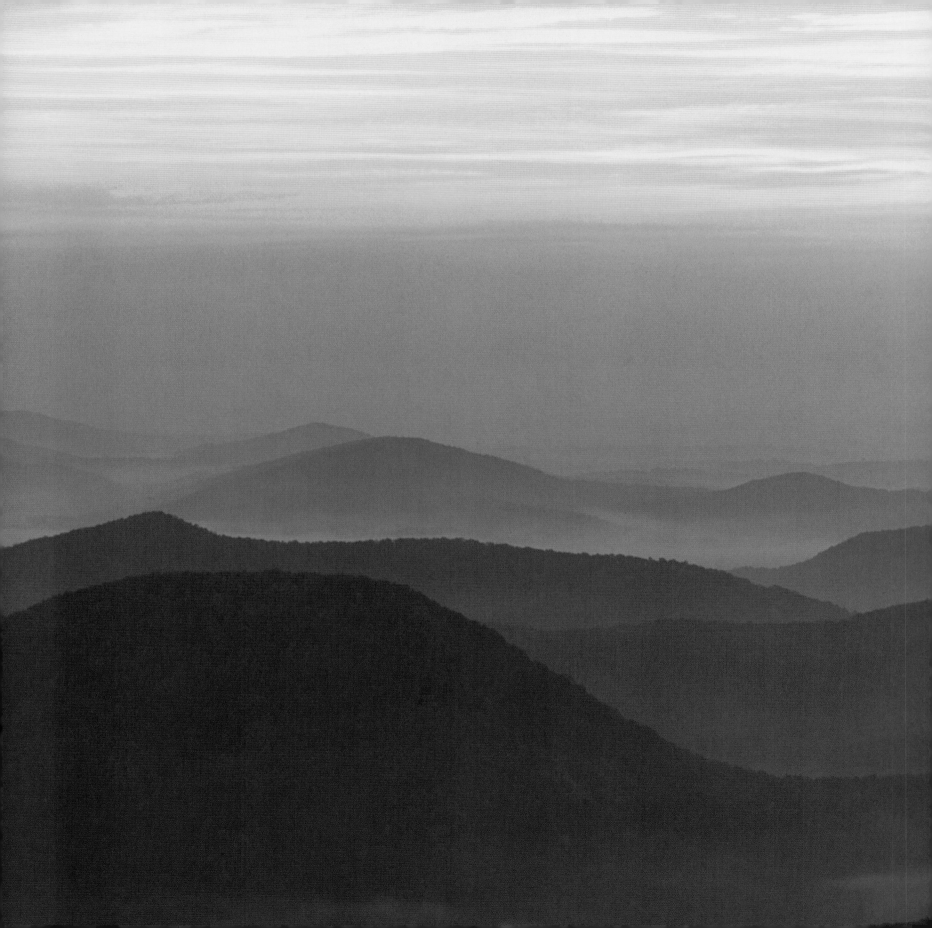

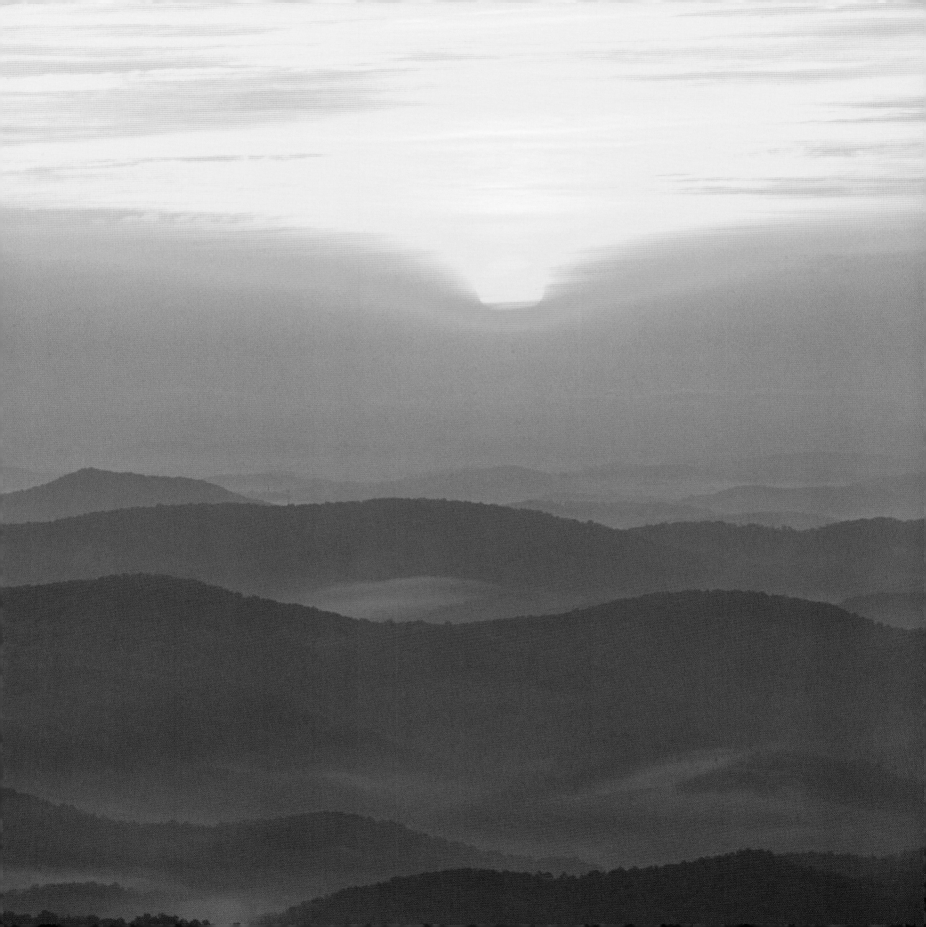

Photo Credits

Hi. I signed in the back
because I can. I'm really
gonna miss you guys 😊 -Arden